Conscientious Objectives:
Designing for an Ethical Message

RotoVision

A RotoVision Book

Published and distributed by RotoVision SA
Route Suisse 9
CH-1295 Mies
Switzerland

RotoVision SA
Sales, Editorial & Production Office
Sheridan House, 112/116A Western Road
Hove BN3 1DD, UK

Tel: +44 (0)1273 72 72 68
Fax: +44 (0)1273 72 72 69
Email: sales@rotovision.com
Web: www.rotovision.com

10 9 8 7 6 5 4 3 2 1

ISBN: 2-88046-751-9

Book design by HDR Visual Communication

Reprographics in Singapore by ProVision Pte. Ltd
Tel: +65 6334 7720
Fax: +65 6334 7721

Printing and binding in China by Midas Printing International

741.6 CRA

Conscientious Objectives: Designing for an Ethical Message

John Cranmer and Yolanda Zappaterra

Acknowledgments

My thanks go out to all the people who so generously contributed their time: Pam Asselbergs, Tsia Carson, Gert Dumbar, Caro Howell, Robynne Raye, Bob Wilkinson, Dirk Bogaert, Susan Kingston, Chris Sharville, and Alan Blackwell. A warm thanks also to Dodo van Aarem and a special thanks to Dan Porter, Lucienne Roberts and Bob Wilkinson. Also to Anne Mary Cranmer. Apologies to Erica Ffrench for all the stress. Thanks also to Andrew Copestake and all at Maya Vision for the time off. I'd like to thank Michael Wood too for no other reason than he's always thanked me in his books. However, my biggest thanks is for my coauthor Yolanda, who is exceptionally talented and patient, and a true professional! Where would the world be without her like?

John Cranmer

As is the case with these things, it's always remarkable how generous contributors are with their time, energy, and involvement, so thanks must go to all of them: those mentioned already by John but also Stefan Sagmeister, Koji Mizutani, Ellie Ridsdale, Mark Randall at Worldstudio, Sophie Thomas and Kristine Matthews, and all the clients and other interviewees who patiently and intelligently responded to our appeals and questions.

As is also always the case, there are people whose names may appear nowhere in the book but who freely gave time, advice, leads, resources, references, and suggestions that range from useful to invaluable, and grateful thanks go to these people as well: Peter Hall, Steven Heller, Alice Twemlow, and Gabriela Mirensky at the AIGA; Jeremy Myerson at the Helen Hamlyn Foundation; Michael Johnson of Johnson Banks; Malcolm Garrett; Jane Roe at RotoVision; Florian Pfeffer at Jung und Pfeffer; and Sheila Levrant de Bretteville, to name just a few.

And finally, there are those who gave support and encouragement throughout the process, amongst whom must be mentioned Erica Ffrench, Paul Murphy, Alkarim Jivani, Don Cornelio and Batfoy, fellow students and tutors at Central St Martins, and last but not least my coauthor John Cranmer. Huge thanks go to all of you for listening, buying wine, and steering us gently through the turbulence.

Yolanda Zappaterra

Preface 7

Past Principles: A History of Good, Ethical 10
Graphic Design, Steven Heller

Current Values: Issues of Ethical Design in Contemporary Practice 18

Practical Issues: Ethical Considerations for Your Design Practice 26

1 **Stefan Sagmeister** **30**
TrueMajority Campaign

2 **S-W-H and Eat** **42**
Ecover Rebrand

3 **Flat Inc.** **54**
Public Service Announcements

4 **Modern Dog Design Co.** **64**
AmphetaZINE

5 **Ellie Ridsdale** **76**
Walking the Way to Health Initiative

6 **Caro Howell and Dan Porter** **88**
i-Map On-line Art Resource

7 **Gert Dumbar** **98**
Bangladesh Birth-Control Project

8 **Worldstudio Foundation** **110**
Sphere Magazine

9 **Koji Mizutani** **132**
Merry in Kobe

10 **thomas.matthews** **144**
The Earth Centre

Bibliography 156

Contact Details 157

Picture Credits 158

Index 159

INTOLERANCE DESTROYS THE FABRIC OF AMERICA

ALL QUOTES WERE FOUND ON INTERNET MESSAGE BOARDS OF MAINSTREAM SITES SUCH AS YAHOO, MSN.COM AND THE WASHINGTON POST

Create! Not Hate. Tolerance Poster Project: www.worldstudio.org
Poster: Jenny Tran + Karin Fong

Preface

"Designers are to our information age what engineers were to the age of steam, what scientists were to the age of reason. They set the mood of the mental environment. They create the envy and desire that fuels the economy and the cynicism that underlies our postmodern condition." Kalle Lasn, Director of the Media Foundation, from *Adbusters*, 1999

Design is everywhere, yet despite its ubiquity, there appears to be surprisingly little of the world inside most of the design being done. Looking around at the numerous tomes that fill acres of bookshelves in thousands of bookshops, neither of us could find a process book dedicated to ethical graphic design. There are books on sustainability and ergonomic product design but precious few on graphics — so we decided to write our own. We also set our targets high; it was a long and hard task wading through all the projects, designers, and companies out there to whittle everything down to the 10 we've included.

Choosing to work for ethical clients and introduce socially responsible design practices is not easy. Working on such projects calls upon new talents in client liaison and design thinking, and we wanted to show real world examples of designers working for and with principles. Many designers are already creating work in the ethical arena, but sadly much of their output is lazy and dull. Clients themselves are complicit in signing off and publishing poor design. Educating clients and raising their aspirations and expectations is essential to helping designers produce fresh solutions. It's too easy to fall back on clichéd images and ideas and we wanted to show what's possible.

Conscientious Objectives strives to bring together an eclectic and international collection of projects reflecting both creativity and excellence in socially responsible graphic design; examples of what can be achieved and examples of what can be done using ethical principles within the creative process. If this collection of case studies is inspirational for designers then it is also educational for clients. Organizations whose budgets are restricted and public remits defined can find examples of how campaigns can work or lobbying be made more effective. Designers are seeking to integrate values back into their working practices and a revolution is underway. Design shapes people's thoughts and desires, their lives even. It's so powerful and so ubiquitous that design graduates should be made to pledge to use their new-found communicative powers for the good and betterment of mankind. As that isn't likely to happen, the best way to prick consciences is to remind designers that it's never been more true that if you're not part of the solution, you're part of the problem!

Past Principles: A History of Good, Ethical Graphic Design

Current Values: Issues of Ethical Design in Contemporary Practice

Practical Issues: Ethical Considerations for Your Design Practice

Past Principles: A History of Good, Ethical Graphic Design

Steven Heller

1860s

The Suffrage Atelier and Artist's Suffrage League develop an iconography which campaigns for women's rights. **Mary Lowndes** creates work using imagery of famous women throughout history. In the UK, women over 30 win the right to vote in 1918; in the US, women are granted the right to vote in 1920.

1880s

Poet, writer and illustrator **William Morris**, rejecting opulence in favor of simplicity, good craftsmanship and good design, sets in motion the arts and crafts movement.

So, is responsible design also good design?

Shouldn't all graphic design be responsible? Not just protest, advocacy, cautionary, or information design—all graphic communication aimed at the public should be conscientious, and, therefore, good. Yet not all aesthetically commendable design conveys worthy messages or promotes harmless products. Cigarette packets generally come in a delightfully colorful box, designed for luring youngsters to buy cigarettes, while the graphics for the antismoking campaign Truth, aimed at ending teenage tobacco abuse, are not always as well designed.

If surface is the criterion—and juried design competitions prove that it is—then ethical practice is minimized when judging much of the profession's most celebrated designs. The mantra "If it looks good it is good" is fairly common. Yet some believe that veneer is only a small part of the design equation. Milton Glaser declares "Good design is good citizenship," which is probably the most perceptive definition of responsible design I've heard. Good citizenship is the inalienable duty of participants in the social contract to take responsibility for their actions—which means design that does not adhere to the standard of good citizenship is irresponsible.

But what is this standard?

For half a century, Glaser has regarded the question as the ethical foundation upon which his commercial practice rests. However, he has concluded that it is more useful to define what is irresponsible rather than what is responsible. Starting with minor misdemeanors and building to major indiscretions, the following 12 prohibitions suggest the lines he believes designers should not cross.

1 Designing a package to look bigger on the shelf.
2 Doing an ad for a slow, boring film to make it seem like a light-hearted comedy.
3 Designing a crest for a new vineyard to suggest that it has been in business for a long time.
4 Designing a jacket for a book whose content you personally find repellent.
5 Designing a medal using steel from the World Trade Center to be sold as a profit-making souvenir of 9/11.

1 I LOVE NY Milton Glaser
Milton Glaser's mantra, "Good design is good citizenship," is applied to this defiant post-9/11 poster for the city of New York.

1917

The October Revolution ushers in a utopian dream best illustrated by constructivist artists El Lissitzky and **Alexander Rodchenko**. Their graphic symbolism for a new age combined asymmetrical compositions, bold type, and elementary shapes to illustrate a new radicalism.

1920s

Marxist and Dadaist **John Heartfield** (born Helmet Herzfelde) develops photomontage as a political weapon, notably in the socialist magazine A.I.Z. (Workers Illustrated Paper) where he attacks Adolf Hitler and the Nazi Party.

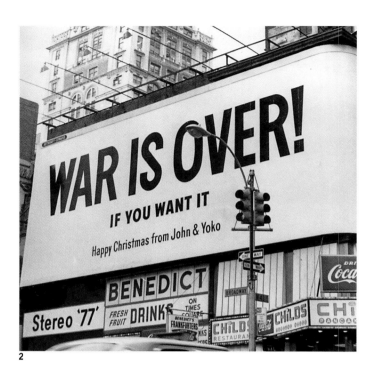

2

2 WAR IS OVER! (IF YOU WANT IT)
This anti-war billboard by John
Lennon and Yoko Ono was a vivid
statement of conscience.

6 Designing an advertising campaign for a company with a history of known discrimination in minority hiring.

7 Designing a package for children whose contents you know are low in nutritional value and high in sugar content.

8 Designing a line of t-shirts for a manufacturer that employs child labor.

9 Designing a promotion for a diet product that you know does not work.

10 Designing an ad for a political candidate whose policies you believe would be harmful to the general public.

11 Designing a brochure for an SUV (Sport Utility Vehicle) which has a tendency to overturn in emergency conditions, and is known to have killed over 100 people.

12 Designing an ad for a product whose frequent use could result in the user's death.

Glaser's list begs the next question: What should designers actually *do* in addition to avoiding these dangers?

All designers would like to think of themselves as responsible, yet as long as international design competitions favor beauty over usability or fashion over accountability, content will take a back seat. Responsible design void of artifice is often ignored by design juries, while at other times a work is so ornately designed it is accepted. What then is the most ethically responsible design? Is it that which conveys a clear, unfettered message in an aesthetically neutral manner, like the ascetic postwar Swiss style? Or is it that which smothers a message with alluring design, like the postmodern New Wave? Actually, neither purity nor ornamentation are cardinal virtues or sins.

In the 1970s, John Lennon and Yoko Ono posted huge Christmas billboards in New York's Times Square and elsewhere. These spoke volumes about human nature by using a few well-chosen words and a simple typeface. The declaration War Is Over (If You Want It), set in black Gothic against an empty white field, was as generic as could be—it wasn't even ethically "minimalist" in a Bauhausian sense. Nevertheless, it was a vivid statement of conscience that was charged with poignancy. Context is everything and this spare composition hanging on a large billboard, sitting next to other

1931	1936
Harry Beck takes information design into a new era with his design for the London Underground system, by laying out a simple map unrelated to the topography above it.	**Otto Neurath** develops the International System of Typographic Picture Education (Isotype), an "international picture language," which lays the foundations for graphic symbols worldwide. Former Viennese colleague Rudolf Modley went on to develop the influential and still popular *Handbook of Pictorial Symbols.*

more lively signs, was as powerful as any bright light on Broadway. The design was transparent, leaving the message supreme and supremely memorable. But not all such heartfelt statements need to be this spare.

During the late 1960s, Seymour Chwast designed a poster that was just as poignant and perhaps more shocking for its accusation. War Is Good Business: Invest Your Son was typeset in an eclectic array of Victorian typefaces, illustrated with nineteenth century engravings, and brightly colored with contrasting purple, green, and orange hues. It was an unforgettable mnemonic against the Vietnam War and an indictment of all the businessmen who profited while soldiers died. The words might have had resonance on their own, without the design accompaniment—presented with such flamboyance, the message was indelibly etched on the minds of all who saw it.

Both posters display social conscience. Both stimulate the public's consciousness. Yet not every spare design is as effective, nor every ornamented one as honest. The nexus of ethically responsible and aesthetically good design is somewhere between under- and overdone and demands both passion *and* intelligence—one without the other means a 50 percent chance of failure.

Examples of cases abound in which one's heart is in the right place but one's type is not. Which is true of New York's ubiquitous choking (or Heimlich maneuver) posters. Restaurants have long been required to post visible instructions to workers and customers on how to help choking victims, and the posters have taught what to do and what *not* to do. Nonetheless, the original poster, which was shabbily designed and printed in nauseating yellow and blue with virtually unreadable type, often failed to impart the necessary lessons, so a few years ago a more colorful iteration was conceived. The improved design is, however, also difficult to read because it is awash with distracting colors and drawings.

While designing an emergency-response poster is not easy, there can be no more important assignment. Somewhere along the line the designer became lost in the artifice of design. Shouldn't one standard of design responsibility be to acknowledge when to do the right thing as opposed to the self-indulgent thing? The question to ask before engaging in work that presumes to be responsible is

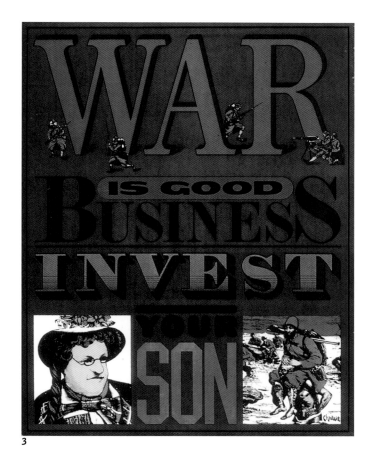

3

3 WAR IS GOOD BUSINESS: INVEST YOUR SON Seymour Chwast's anti–Vietnam War poster offered a stark reminder about the economics of war.

1936–1939
The Spanish Civil War creates an astonishing wealth of images (including films) that not only exhort people to fight Fascism, but also illiteracy, disorganization, and poverty.

1940s
Abram Games' work for the War Office was an early example of graphic design's power to persuade, inform, *and* educate all at once. Much imitated, he was never bettered.

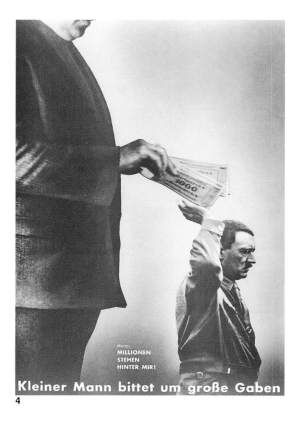

Motto:
MILLIONEN
STEHEN
HINTER MIR!

Kleiner Mann bittet um große Gaben

4

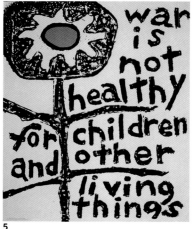

war
is
not
healthy
for children
and other
living
things

5

"will my work significantly benefit, indeed enlighten, its audience"? If the answer is "I don't know" or "Maybe, but it sure makes a great portfolio piece," then one's priorities are askew. The designer's first responsibilities are to the cause, the issue, and the audience.

What can be learnt from the past?

Modern art and design history reinforces the ethical role of graphic design. From the social reformers in the Arts and Crafts movement, who believed that handmade utilitarian output was more vital to society than mass-produced, machine-made pap, to Machine Age futurists, who believed that adhering to the rightness of form rooted in new technologies was the highest attribute, design has been a tool in the conscientious objectives of many cultures.

European designers adhering to or influenced by ethical tenets of midcentury modernism have long sought to balance personal art and social responsibility. Bauhaus, *de Stijl*, constructivism, and their offshoots developed ethical standards whereby the artistic ego served the needs of communications. John Heartfield's classic 1930s election poster for the German Communist Party is a prime example of a utilitarian creative design. This poster features a photograph of an outstretched, dirty, worker's hand—its five fingers grasping for power—representing the fifth line of the election ballot where the Communist Party's name was to be found. Heartfield invented a mnemonic that told the voter exactly where to vote, and why. The image brilliantly symbolized the party of the working class that was both powerful and memorable yet void of graphic excess. It was not only an appropriate use of form but also an ethically generous act on behalf of the designer to represent his cause.

However, sometimes conscience overpowers reason and any professional notions of good design are sacrificed in the process. When the goal to produce anything that will advocate a cause or policy overrides all else, the end result is more direct and aesthetics are less important. Indeed, many important designs are triggered by instantaneous reaction to overwhelming crises, and none is more gripping than war.

In the archive of proactive graphic design, war protests are the most memorable, and the most unforgettable is Lorraine Schneider's 1969 poster for the American grass-roots group Another Mother for

1957

Vance Packard's *The Hidden Persuaders*, a scathing critique of advertising's exploitation, is published. Sensationalist and flawed at the time, it is unerringly prescient.

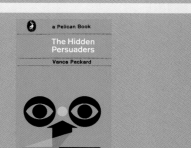

a Pelican Book

The Hidden
Persuaders

Vance Packard

1958

Royal College of Art graduate **Gerald Holtom** designs the peace symbol for the Campaign for Nuclear Disarmament (CND). It appears as a cardboard lollipop on the first major antinuclear march in the UK.

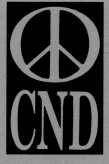

CND

Peace, a hauntingly sketched flower around which is scrawled the phrase War is Not Healthy for Children and Other Living Things. Instantaneously the slogan became the mantra of the anti-Vietnam War movement and had more widespread appeal than many of the more acerbic satires against the War's perpetrators because it was void of sarcasm and irony. It spoke simple truth to folly by addressing the devastating effect of war on everyone, regardless of positions for or against. Yet it never appeared as a design award winner.

Likewise, another memorable antiwar poster with a headline that read And Babies...? And Babies... showing a color photograph (taken in 1969 by army photographer Ronald Haeberle) of lifeless women and children strewn along a road outside the remote Vietnamese village of Mai Lai, was a visual testament against war's horror. Out of a war that produced countless memorable images, this one was the most damning because it proved that atrocities usually ascribed to America's enemies were committed by Americans. Again, it was never awarded an art director's medal.

In fact, to bestow professional honors on statements such as these ultimately diminishes their purpose. To judge artifacts that respond to human tragedy by the same standards as a book jacket, wine label, or cigarette package is to trivialize them; to judge them critically as responsible design it is necessary to define our terms.

How should new media be utilized?

In the wake of the Vietnam War, responsible design became a given and designers are now expected to speak out on issues of the day. Consequently, it was surprising that during the first Iraq War the graphic response was less prodigious than it was during the Vietnam War. Of course, the brief Desert Storm was hidden behind a news blackout, which meant that design activists barely had a chance to churn out quick copy flyers—forget eloquence. Only after a few months did antiwar advocates find a viable hook for their protest by utilizing the idea of "collateral damage," military-speak for unintended civilian victims of combat. Focusing attention on innocent dead had rallying power that eventually inspired a bevy of crude posters and missives. Those with the most impact were decidedly ad hoc in appearance.

The response to the second Iraq war was quite different from the first owing to the power of email and Internet for widespread

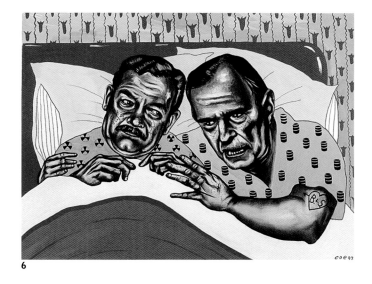

6

4 A SMALL MAN IS ASKING FOR GREAT GIFTS John Heartfield used montage as an effective tool against political injustice in Germany during the 1930s.

5 ANOTHER MOTHER FOR PEACE Lorraine Schneider's poster for 1960s grass-roots antiwar group Another Mother for Peace is still used today.

6 SADDAM AND BUSH IN BED TOGETHER Sue Coe, 1992. Coe is committed to extending the reach of subjects that she feels are not adequately covered by mass media.

1960s
The arrival of underground magazines *IT*, *Yarrow Roots*, *Gandalf's Garden*, *OZ*, and *Black Dwarf* reflects the antiestablishment, idealistic counter-culture of 1960s youth.

1961
Lawyer **Peter Benenson** "founds" Amnesty International (AI) through a newspaper article. From the outset, AI's graphics, ads, and direct-mail campaigns pull no punches, using shock tactics at their best.

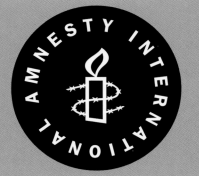

and rapid communication. Protest messages sent to millions of electronic mailboxes spread throughout the wired world. This type of campaigning began with worldwide antiglobalization protests against the World Trade Organization in the late nineties. Activist designers engaged in "culture jamming" (a term coined by *Adbusters* magazine), whereby commercial billboards and advertisements were defaced or transformed into commentaries against an encroachment of multinational brands that were accused of exploiting workers and entire cultures.

With this new media explosion of conscientious expression, anyone with a computer and production software can launch a personal campaign. Such is the case with copywriter Micah Wright, who saw his design responsibility as a personal effort. His Propaganda Remix Project was a continuously replenished supply of retrofit World War II posters with caustic new slogans, which are still available as free downloads to anyone who wants to print one. Among them is a poster featuring Uncle Sam in rolled-up shirtsleeves (originally anti-Japanese propaganda) with the headline referring to the US Attorney General, Ashcroft... You're Next! Break Our Constitution, I Break Your Face. Another shows attacking GIs (originally a D-Day message) bearing the words Attack Attack Iraq: Another War Will Surely Pull Us Out Of Recession! While they tickled a nostalgic fancy they also raised questions about the US's preemptive strategy.

Wright's work is an extension of the historical legacy established by the situationists in the 1950s. It also shows that satire is the most viable way to critique political and social issues. In fact, acerbic humor is often used like an axe to break through a mass-media log-jam that the "alternative" media seeks to augment with countervailing commentary. Satire is comprised of one part absurdity and nine parts truth, so parody and comedy that ridicule and humiliate or otherwise illuminate a social and political folly is a key weapon in the limited arsenal of the artist and designer.

Guerilla designers who attack social and political follies employ it full bore. Klaus Staeck, the German artist and social critic, was a master of ironic photomontage, in the tradition of John Heartfield, who used mass media (postcards, posters, t-shirts) to critique German ills. Similarly, California-based Robbie Conal, a master of "'infotainment," believes his job is to subvert government hypocrisy.

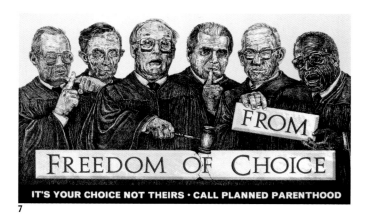

7

7 FREEDOM FROM CHOICE
Robbie Conal is the master of what he calls "infotainment," which he uses to subvert government hypocrisy by supporting such issues as abortion rights.

1964

Jock Kinnear and **Margaret Calvert** design the Transport Alphabet series font for the Worboys Committee, marking the way for legible road signage throughout the UK.

1964

Design's contribution to the 1960s counter-culture—**Ken Garland**'s first things first manifesto for designers and design practice—has had a lasting impact. In the 40 years since its inception, it has consistently played an important role in design discussion.

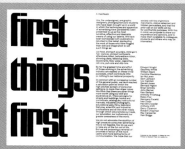

He supports abortion rights and welfare reform, and attacks police oversight through posters he illegally wheatpastes around American cities.

Poster sniping and billboard "repositioning" is not just an American phenomenon. Groups of socially conscious designers in The Netherlands (including Wild Plakken) and France (Grapus), and other groups in cities throughout the world, were prodigious producers of street images in the 1970s, 1980s, and 1990s. Further, kindred groups and individuals sought to build networks of graphic designers to propagate socially controversial messages to various constituencies. That they did so using a variety of styles, ignoring a single dogma, shows the essence of responsible and good design. But in the final analysis, ethically responsible design is only as good as the message it projects or the information it conveys. If the message is bad then the design has no value; if the design is bad, the message suffers. So design must enhance, and good responsible design makes people think, question, learn, and act.

Steven Heller is coeditor of *Citizen Designer: Perspectives on Design Responsibility* (Allworth Press), and author of *The Graphic Design Reader* (Allworth Press), and *Merz To Emigre and Beyond: Progressive Magazine Design of the Twentieth Century* (Phaidon Press)

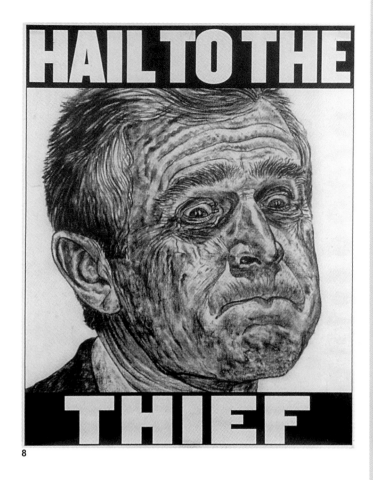

8

8 HAIL TO THE THIEF Robbie Conal's now famous "adversary portrait" of George Bush.

1966

The Black Panther Party for self-defense is founded in October by **Huey P. Newton** and **Bobby Seale**. Its powerful, aggressive graphics reflect its militant, proviolence stance.

1968

NOW (National Organization for Women) becomes the first US organization to call for the legalization of abortion and for the repeal of all antiabortion laws. Women's rights in general are illustrated by groups like the **Chicago Women's Graphics Collective**, which turned artmaking into a collective process.

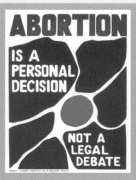

Current Values: Issues of Ethical Design in Contemporary Practice

"Design doesn't have to reinforce the status quo; it can be instrumental in change, in making the world a better place to live in." Lucienne Roberts, Designer, sans+baum

1968

French students take to the streets, armed with striking handmade posters by art collectives such as the **Atelier Populaire** and Ecole d'Art, from which emerged one of the century's most important social design collectives, Grapus.

1970s

The decade of agitprop sees virulent antiwar graphics throughout the US by designers, illustrators, artists, and activists such as **Tomi Ungerer**, Synergisms, Jay Belloli, Seymour Chwast, and Ed Sorel.

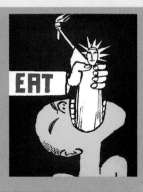

Commercial ethics

Graphic design is a competitive, cutthroat world. There is no one way to be ethical as a designer and probably no one designer who is 100 percent ethical. But there are different approaches to socially responsible practices regarding who you work with, what you produce, and how you work. Establish in your own mind a threshold of what you can tolerate in others and are prepared to do yourself. How can a large advertising agency produce seductive images encouraging cigarette sales *and* create government campaigns on the dangers of smoking? Can anyone still hide behind the excuse that they are simply apolitical communicators and take the cash? But if they don't, how can they survive professionally?

Mixing commercial and not-for-profit work is the way many designers express an ethical stance. Dutch design company Eat has worked for "museums, an airport, banks, newspapers, supermarkets, and telecom companies... Not companies with especially strong ethics," explains Pam Asselbergs, designer at Eat. But Eat has also designed for international organizations for the visually impaired, children's aid funds, and a correction institute for juveniles, and through such a varied client base, has won the opportunity to work for a commercial client whose ethics are as impeccable as they come—Belgian detergent company Ecover. Together with Dutch advertising agency S-W-H, Eat rebranded and relaunched Ecover into international markets, spreading its ecological message. As part of that rebrand, a poster campaign won S-W-H an Art Directors Club of Netherlands (ADCN) award.

Opportunities to work with perfect commercial clients are few, a fact of which Sophie Thomas of UK design group thomas.matthews is aware. "I think the main point is, you can't always be squeaky clean. So if you work with large corporations then make sure you take your ethics and persuade them to change." That might sound like commercial suicide, but for thomas.matthews it has been a successful ethical strategy. "Our work comes from our reputation and through recommendation. We have turned down a few dubious clients but haven't really suffered from doing so. If you set yourself up as having scruples you usually attract the clients who appreciate that. Sometimes the most interesting jobs are with those clients who aren't ethically minded but can be persuaded or pushed!"

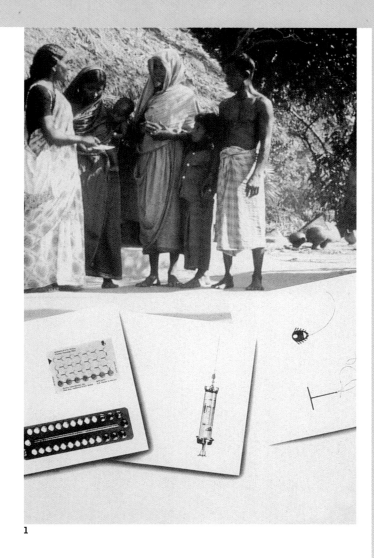

1

1 BIRTH-CONTROL POSTER This poster, by Gert Dumbar, was part of a radical and pioneering work to bring ideas of birth control to the illiterate rural population of Bangladesh.

1970
Designer and environmental artist **Sheila Levrant de Bretteville**, a signatory of Garland's first things first manifesto in 1964, founds the Feminist Studio Workshop and the Woman's Building (an alternative center for women in the arts) in Los Angeles.

If the designer is to make a deliberate contribution to society, he must be able to integrate all he can learn about behavior and resources, ecology and human needs;

taste and style just aren't enough.

School of Design

1971
Victor Papanek publishes *Design for the Real World*, challenging the dominant, market-led approach to industrial design, and calling for more social responsibility from designers.

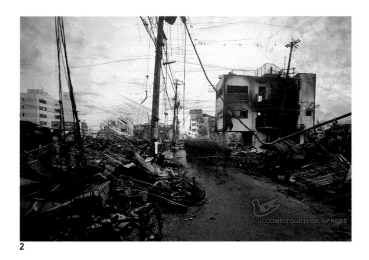

2

2 COME TOGETHER FOR KOBE
This poster, art-directed by Koji Mizutani, aimed to show the extent of the earthquake devastation in Kobe that he felt mainstream media were avoiding.

Commercial ethics

The client question has engaged Austrian-born Stefan Sagmeister. "While we were busy in the 1980s talking about layouts and lifestyles, lived through the 1990s discussing readability, layering, and money, there is now finally time to think about what we do and for whom we do it." Such issues prompted 33 designers and critics to sign a reissued version of Ken Garland's seminal 1964 manifesto, first things first 2000, stating that the "profession's time and energy are used up manufacturing demand for things that are inessential at best," and that "unprecedented environmental, social marketing, and cultural crises demand our attention." Calling for designers to shift their priorities in favor of useful, lasting, and democratic forms of communication, it was a wake-up call to the slumbering conscience of the design community.

For Japanese designer Koji Mizutani, such a wake-up call took the form of a natural disaster. "Everything was over the limit. I did nothing but make adverts which simply were about making money for the big corporations, whose relationship with the designers was like that of the royal court and painters during the Renaissance." For Mizutani, the greed-fuelled work burnt itself out and left him with the observation that corporations themselves should do good for society and people, as should designers. "I'd become a graphic designer," he recalls, "so that I could send a message, and I'd lost sight of that." His work following the Kobe earthquake in Japan brought humanitarian values back into his life as a designer, and his design work itself.

"Design is quite successfully positioning itself as an important tool for companies trying to serve clients through the market; we are looking for mechanisms to serve clients and needs that fall through the cracks of the market." Dirk Bogaert, Director, Design for the World

1976

Bank clerk **Mark Perry** starts the first UK punk fanzine, *Sniffin' Glue*, after seeing punk band The Ramones. He took the unskilled do-it-yourself aspects of punk and applied them to journalism to create a new form of self-publishing, available to all.

1977

The Buzzcocks release "Spiral Scratch," the first independent single of the New Wave, on their own independent label, New Hormones. The sleeve, designed around a Polaroid taken by manager **Richard Boon**, is produced for £500 (c. US $800), and marks the beginning of a remarkable do-it-yourself aesthetic in UK culture.

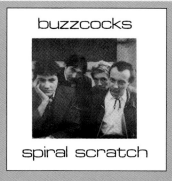

Effective design

Design itself is an integral part of the ethical equation. For Tsia Carson of New York design group Flat, "every designed object is in part social. Whether it's a laser-guided missile, a genetically designed seed, a voting ballot, or a book for children." Where the social dimension to design is sometimes overlooked, Flat's series of Pubic Service Announcements are clearly focused. Carson's reference to a voting ballot is an acute reminder of the controversy around the voting in Palm Beach, Florida, for the election of the US President in 2000. Everyone recognizes that the poor design of the ballot paper in this instance had undemocratic consequences. It also brought a host of public responses from the design community, including one from Paula Scher of Pentagram in *The New York Times*, where her critique pointed out that many corporations or official bodies approve of documents or products that are incompetently designed. Accepting that, you have to wonder exactly how much damage thoughtless design has done globally and to individuals.

In the UK a major design blunder, which would have isolated and disenfranchised millions, was narrowly averted. Engineers with little knowledge of the extent of visual impairment among the population were setting technical standards for TV subtitling. Fortuitously, Dr. John Gill, Chief Scientist at the Royal National Institute of the Blind, happened to be watching television with subtitles and realized how poor the legibility was. When he discussed the issue with a friend in the television industry, he was shocked to learn that within a fortnight, the existing screen font was scheduled to be embedded in digital set-top boxes. Dr. Gill quickly briefed designer Chris Sharville to develop and design a new font. "Our initial design commission," explains Sharville, "was to examine the requirements for subtitling on the new digital television systems." After looking at the nature of screen displays and how they affected character shape, Sharville eventually designed the font Tiresias, which has since been included in European regulations for digital television standards. With interactive screen displays becoming smaller and the amount of information shown becoming larger, there are problems looming again. "People with low vision find it very difficult to use these systems. Designers today must carefully consider the typefaces they choose for screen systems."

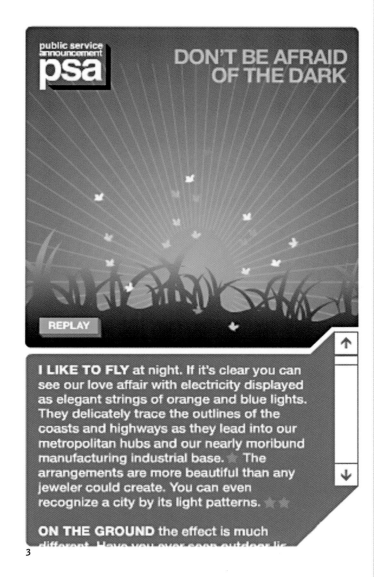

3

3 PUBLIC SERVICE ANNOUNCEMENT
One example of Flat Inc.'s playful twist on the usually dry Public Service Announcement, with a political sting.

1979
Peter Kennard's photomontages for CND powerfully raise awareness of the movement and kickstart mass demonstrations against nuclear weapons in the UK.

1980s
Artist **Barbara Kruger** uses the tools of her former career in design to combine found photographs with pithy and aggressive text that addresses issues of feminism, consumerism, autonomy, and desire.

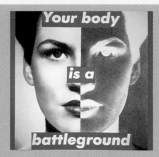

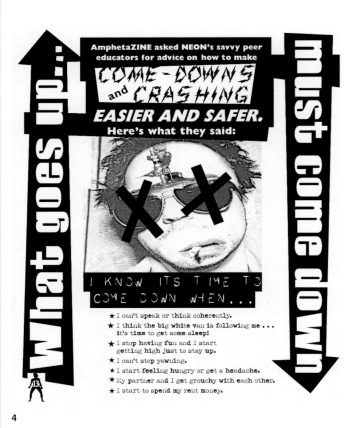

4

4 *AMPHETAZINE* Modern Dog
Design Co.'s solution to health
information for crystal
methamphetamine users.

Design legislation

It would be good to think that most designers would take legibility on screen or in print into account through altruistic reasons, but the real push may come from legislation. In the UK the *Disability Discrimination Act* (1999) is slowly being phased in, and in the US two pieces of recent legislation directly affect design; the 1998 amendment to Section 508 of the *Rehabilitation Act* and the *Americans with Disabilities Act* (ADA). The UK's Act has a broad definition of disability which includes people with dyslexia or adult learning difficulties, as well as visual impairment, all of whom might have to be included in any future briefs to avoid breaching the law. The ADA's design guidelines include the use of Braille and large-print signage, and Section 508 of the *Rehabilitation Act* covers "any electronic and information technology that is developed, maintained, procured, or used by the US Federal Government." It gives people with disabilities "access to and use of information and data that is comparable to the access of those without disabilities." As the section specifically refers to services provided both by and for the US Federal Government, the implications could be wide, covering products and services such as websites, software, product documentation, technical support, training, and other publications such as forms or information.

Demographics too are pointing to a surge in legibility issues. Across the US, Canada, and Europe there is a looming crisis of an ageing population. With old age comes decreased visual acuity and a wealth of degenerative ocular diseases. Frank Philippin, a research associate at the Helen Hamlyn Foundation at the Royal College of Art in London, has produced a timely report, *Small Print: Improving Visual Pack Information for Older Consumers*. Clarity and legibility are becoming major concerns. Accessibility will need to be at the forefront of all design education in the future.

Inclusive design

As it stands, there are many areas in current design education that are being overlooked, leaving some students lacking key communication skills and understanding of a brief. Another research fellow at the Helen Hamlyn Foundation, Ellie Ridsdale, found her education constricting when she had to address the

"I think there are very few projects where a designer has a chance to really make a difference. As long as we are in business, we will take nonprofit work for social causes we believe in." Robynne Raye, Designer, Modern Dog Design Co.

problem of how to get a message about the health benefits of walking across to users. "Coming out of design education, it's hard to design for the user," she explains, "because at college you design for the designer, your peer group, rather than the user, and they're very different things." This left her with problems when she became involved with the British Heart Foundation's Walking campaign, and had to design a range of posters promoting walking. "The focus groups and users needed signifiers that a hip, design-savvy audience wouldn't need at all, such as a banner, because, for them, that was what made a poster a poster..." It might sound a trivial point, but without users being able to recognize what they were shown, it was likely that the whole project could fail as a result of the information being downgraded in importance, or even ignored.

Being able to speak graphically in a language that communicates effectively with a target group outside the designer clique is obviously core to inclusive, accessible design. It crops up again and again. It was an issue which Gert Dumbar faced 20 years ago in producing a poster to demonstrate birth control to the rural illiterate population in Bangladesh. Government funds available for the project meant he was able to set up a group to tackle the issues involved and undertake ethnographic research, which directly impacted on many aspects of the resulting designs.

In Seattle, Michael Strassburger and Robynne Raye of Modern Dog Design Co. also had to find ways of reaching a target group outside the clique of designer culture—crystal methamphetamine drug users. The target group might have been urban North Americans, but Strassburger and Raye had to ignore the more fashionable graphic vernacular to develop a homegrown punk fanzine style for the health

"Using the tools of graphic design to persuade someone to be more tolerant is, probably, more difficult than trying to persuade them to buy a certain brand of dog food."

Michael Bierut, Partner, Pentagram

1987
Ten New York members of the AIDS Coalition to Unleash Power (ACT UP) form **Gran Fury**, to provoke direct action to end the AIDS crisis and take informative art—images they believed more compelling when accompanied by words of explanation and elaboration—beyond the gallery.

1990s
Self-taught designer, illustrator, and artist **James Victore** begins producing his subversive polemic posters on everything from the AIDS crisis to racism, and the Disneyfication of New York.

> "The very nature of graphic design leads designers to fulfil the role of social commentators... The commentary is visual, it is sexy, and it can grace the pages of industry publications."

Mark Randall, Founder, Worldstudio Foundation

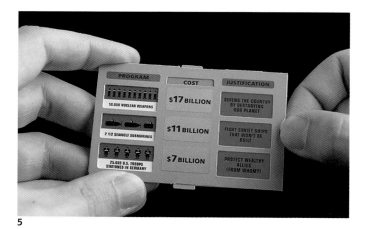

5

promotion pamphlet, *AmphetaZINE*. The strategy worked and has saved lives. They approached the whole project as one of inclusivity, not preaching or talking down to what many consider not just an unreachable social group but an untouchable one.

In the UK, inclusivity was the drive behind Caro Howell and Dan Porter's i-Map for the Tate Modern gallery, an online art education resource for the blind and partially sighted. Art is a major part of contemporary culture, and Howell and Porter were determined that no one should be excluded from the debate surrounding it or the enjoyment of indulging in it. "The ethos behind i-Map, and all my work at Tate Modern, is that no art or idea is 'out of bounds' to blind or partially sighted people," says Howell. With i-Map, Howell and Porter have raised the technical and pedagogical standards for all designers, and their dedication to the principle of inclusivity in art should be taken on board, especially by designers, who too often choose not to engage with such issues.

In the US, the not-for-profit Worldstudio Foundation is doing its best to jolt designers out of such disengagement. Funded in part by its for-profit design studio, Worldstudio, Inc., the foundation exists partly to inform designers through an annual magazine *Sphere*. "Our goal in creating it was to highlight the social and environmental work of artists, architects, and designers we admired. To inspire other creative professionals by example," explains founding partner Mark Randall. Initiatives such as student mentorships and scholarships are also the remit of the foundation. "The main business of graphic design exists to serve commerce, which I have no problem with, but it's great to develop a project that has a message you can truly believe in," enthuses Randall. It's rare to find a design group that balances commerce and ethics so skillfully.

Like ethics in the real world, this book is a compromise between the ideal and the practical. We couldn't cover everything, but our hope is that the case studies we have looked at will stimulate others into thinking about their own work and working practices as well as show that this is not a trivial or marginal area. Issues such as copyright are ones we would have liked to include but were unable to. But that doesn't mean things aren't changing. For example, ideas such as Copyleft, a particular form of Copyright that includes special distribution terms, are gaining in popularity. Design for the World's

1990

Ad agency **McCann Erickson** creates a brilliant 44-sheet billboard ad for Friends of the Earth. Made of litmus paper, it literally educates the UK about acid rain, fading to nothing to show the effects of London's corrosive atmosphere.

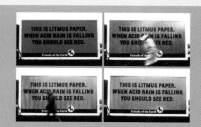

1991

Tibor Kalman goes to work for Oliviero Toscani, Creative Director of Benetton, creating *Colors*, a magazine which continues the fashion company's tradition for controversy through shocking imagery.

Director, Dirk Bogaert, explains that "it certainly seems adequate for many of our projects in that it maintains credit where credit is due and protects ideas from being hijacked."

How you practice your trade is down to you. Do you drop that bottle into the trash or a recycle bin? At first it's a choice, but then it becomes a habit, and the world becomes that much better for it. It is rooted in the fable of a man perplexed by the behavior of another man who, on a beach littered with millions of dying starfish, is throwing them back into the sea, one by one. "You can't make a difference, there are millions of them," says the first man. "It can make a difference to this one," retorts the second as he hurls another back into the sea.

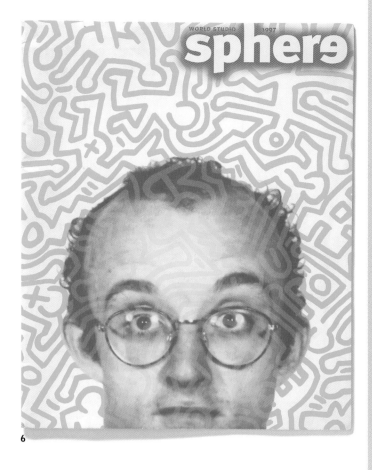

5 SLIDE CARD FOR TRUEMAJORITY CAMPAIGN Stefan Sagmeister's slide card reveals facts on US Government spending.

6 *SPHERE* MAGAZINE COVER Design meets social, political, environmental, and educational issues in Worldstudio Foundation's magazine.

1991

Big Issue launches in London. Sold by the homeless who keep a large percentage of the profits, the magazine's feel reacts against the "greed is good" ethos of the 1980s, ushering in a more caring 1990s.

1993

Canadian culture jamming begins with the launch of *Adbusters*, a magazine promoting creative resistance everywhere. Now world famous for promotion of events such as Buy Nothing Day.

Practical Issues: Ethical Considerations for Your Design Practice

1998

The Tiresias font, aimed at clear on-screen legibility and named after Sophocles' blind seer, is developed by **Dr. John Gill** (Chief Scientist, Royal National Institute of the Blind), **Dr. Janet Silver** (former Principal Optometrist, Moorfields Eye Hospital), **Chris Sharville** (Creative Director, Laker Sharville Design Associates), and **Peter O'Donnell** (Type Consultant).

ABCD
ABCDEFGHIJKLMN
OPQRSTUVWXYZ&
abcdefghijklmnop
qrstuvwxyzàçéîðñ
1234567890 $€
The quick brown fox jumps over the lazy dog.

2000

Designer and illustrator **Luba Lukova**'s poster Sudan is commissioned by New York group the International Anti-Poverty Center to raise awareness of Sudanese poverty among international lawmakers. It illustrates the contrast between the weight-obsessed West and other countries, where people don't have anything to eat.

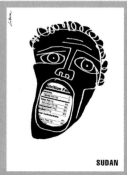

SUDAN

The Way You Work

(or, making business ethical)

Make your company a partnership, a co-op, or employee-owned

Explore partnerships, worker-run co-operatives, or employee-owned businesses as ethical alternatives to the far-from-model business model. In the UK the Co-operative Movement (www.cooponline.coop/) and the Co-operative Union (www.coopunion.co.uk) have a wealth of information. For European advice go to The European Business Ethics Network (www.eben.org/), for US advice contact the National Center for Employee Ownership (www.nceo.org/).

Share the profits and rip off no one

Intellectual property and copyright have become increasingly thorny issues with the age of the Internet, so know your copyright— both yours and the people you work with. You should also ensure that, where you use images featuring other people, those people, or an organization benefiting them, receive remuneration. Establish this with the photographer or photo library before signing up with them, and make sure this is covered in any written contracts. The World Intellectual Property Organization (http://www.wipo.org/) details virtually every aspect of copyright and intellectual property rights around the world. UK designers may find the Government-backed intellectual property site (www.intellectual-property.gov.uk) useful as it does include local advice.

Determine good working practice in the workplace

From keeping staff healthy and happy to making your business accessible to the disabled, and implementing good pensions, workplace issues can require a lot of specialized knowledge. A good starting point for US designers is the US Business Advisor (www.business.gov/busadv/maincat.cfm?catid=23), which incorporates everything from discrimination and disability acts to safety and well-being.

Take care of the finances

There is no reason to deal with unethical professional organizations. Before signing up with any bank, solicitor, accountant, or property owner, do a background check on them and/or ask them about their ethical policies. Where and how do they invest your money? Who do they work with? Are they a slum landlord? In the UK, Triodos Bank offers an ethical bank account at www.triodos.co.uk, while money.guardian.co.uk/ethicalmoney, a *Guardian* site, has a plethora of useful advice and information on all aspects of ethical money. The factsheet on ethical companies on this site is well worth a look too.

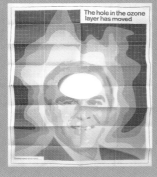

2001

UK design group **johnson banks** creates a stink with its Design Council report into sustainability using fossilized nappies. Its anti–George Bush poster, which highlighted the expansion of the ozone hole, was equally powerful and witty. Both show how educational tactics needn't be shock tactics.

2001

The books *No Logo* by **Naomi Klein** and *Fast Food Nation* by Eric Schlosser are published to critical acclaim and massive sales. Despite being sociological explorations of rampant Western consumerism and exploitation, they sell well to a growing politicized, angry, readership.

Who You Work With

(or, knowing other people's business)

Choosing your clients

As a designer, one of the most difficult aspects of ethical practice is choosing your clients, a choice affected by any number of variables. What you can do, however, is determine your criteria for working with somebody. If they are an ad agency, who are their clients? If they're a company, are the products or services they promote ones that you find repellent? Are they exploitative in their production or discriminatory in their hiring? Are they honest in their claims for their services/goods? Once you have this list, choosing your clients will become much easier.

Choosing and employing contractors

Who you work with is an integral part of how you conduct your business. When and where you can, you should set the terms for the contract of work/provision of goods. With freelancers—illustrators, photographers, designers, etc—it's good to have a standard contract that clearly states your, and their, requirements. If they're on a daily rate, how many hours is that? Is overtime paid? What are the payment terms? Can you ensure that what you require from them will not result in exploitation further down the line? Are they willing to sign a contract to that effect?

Choosing suppliers

Before choosing a supplier, do some investigation into their practice and products. If they sell recycled paper, what kind of recycled? If it's ink cartridges or office supplies, is there any form of recycling offered? Instead of using anyoldcateringsupplies.com, phone your local Oxfam or organic delivery service and ask them if you can set up a regular order for delivery of Fairtrade goods and/or local produce.

2002

UK disability charity **Scope**, together with **Transport for London**, adjusts Beck's original map for the London Underground to include details of disabled access for the first time.

2002

Sheila Levrant de Bretteville works with Scott Stowell and Susan Barber to design this antiwar ad for working group NION, which appears in *The New York Times*.

How You Work

(or, the challenge of creative integrity)

Be honest in your designs

Steven Heller's overview (p 10) quotes Milton Glaser's 12 prohibitions for good design. These boil down to two things, honesty and integrity. Are you prepared to design packaging/an ad/a poster/a book jacket/a brochure/a title sequence/a website that makes false claims for its content, be it through size, copy, imagery, material, or promotion? There is no gray area here. Less clear-cut is integrity, with its blurring of the personal and the political. Would you create a campaign for a policy you disagree with, or work with content you personally find repellent?

Be inclusive in your work

If a vitamin product counts the elderly among its target user group, don't set the type in youthful 6pt because it will appeal to other desired users; young mothers-to-be, athletes etc. Insist on doing your own research and set up your own focus groups; include as many target groups as will be using or affected by the service/product as possible, then listen to them. Learn from them, from your own research, and from contextualization.

Be prepared to fight the client

Educating the client, raising their awareness, and making them face issues they may not want to address is an integral part of the designer's role. If they want the impact of their fund-raising poster to be powerful and equate that with shock tactics, prove that there are alternatives. And there are always alternatives.

2003

Micah Wright's Propaganda Remix Project includes *You Back the War: We'll Bomb Who We Want*, a collection of 41 protest posters.

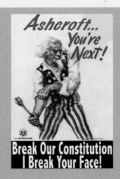

2003

Fuck the War exhibition opens in London, featuring anti–Iraq War print work by the collective **Hotel Belville**.

Stefan Sagmeister
TrueMajority Campaign

1

Stefan Sagmeister is a commercial designer, but he never puts commercial considerations above all else. His work includes such philanthropic projects as a poster campaign to welcome his friend Reini, and a business card consisting of a dollar bill for his then girlfriend. In September 2000 he closed his studio to travel for a year, but one project continued through this: a five-year, ongoing political lobbying project.

Political lobbying

Stefan Sagmeister met Ben Cohen, co-founder of Ben & Jerry's ice cream, shortly after Ben sold the company and founded a nonprofit group, Business Leaders for Sensible Priorities, consisting of a few hundred CEOs of large companies and a smattering of military and religious leaders. Both men were speaking at a Technology Entertainment and Design (TED) conference in Monterey, California, where Cohen outlined his coalition's concerns, namely to bring about the reduction of the Pentagon military budget from a level that was just 10 percent short of what it was during the Cold War to something more rational. That would, as Cohen pointed out, still give them the nuclear capability to destroy every city in the world fourfold. Sagmeister recalls being impressed with Cohen's aims and seriousness. "We met up in the room of Tibor Kalman later on and immediately liked each other. We decided to meet up to talk further about ways of lobbying for the redistribution of military spending." From these meetings emerged a Business Leaders initiative called Move Our Money. "Move our Money basically had only one, single goal: to cut 15 percent of the US military budget and move it over to healthcare and education. I thought this goal specifically remarkable, coming from business leaders who you'd normally associate with Republican causes—this was not just a bunch of hippies with a good idea and no way or means to achieve it."

1.1

1.2

1.3

1.4

1.5

1.6

1.7

1.8

1.9

1.10

2.1

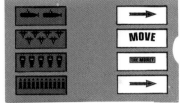

2.2

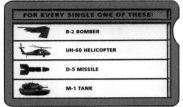

2.3

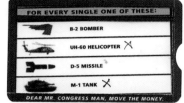

2.4

3

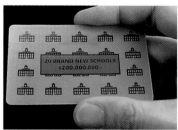

4

1 INITIAL SKETCHES In order to promote the Move Our Money campaign in a roadshow, Sagmeister began to work up ideas for a series of information graphics that could be shown on several different elements. The staggering figures involved in military spending offered a direction that would look at how much could be achieved in social spending with just a fraction of the money spent on military equipment.

2 PRESENTING THE FIGURES An early decision was to create a pocket-sized slide card that would show the hard facts and figures on one side and explanatory text, addresses, and a global military chart on the reverse.

3 SLIDE CARD With a wealth of information on figures and so many ways of making comparisons, it was difficult deciding which facts to use on the card.

4 MOVE OUR MONEY PEN This pen is just one example from a range of free merchandise designed by Sagmeister.

5 MOVE OUR MONEY CARD By tilting these "winky dink" cards you see two sets of graphics, one showing an F-22 fighter jet and its cost—US $200,000,000—and the second showing the same figure with pictograms of the 20 schools such a sum would pay for. "We were going to use a B-2 Bomber but the number of schools you could buy for the same money was so big they wouldn't fit on the card," recalls Sagmeister.

5.1

5.2

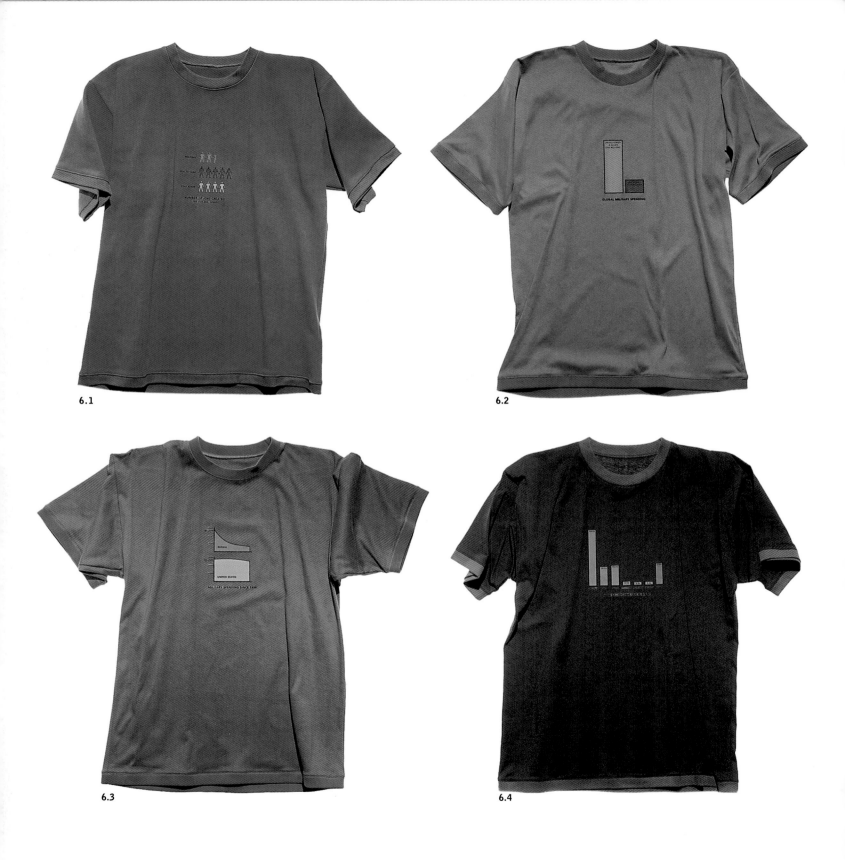

6.1

6.2

6.3

6.4

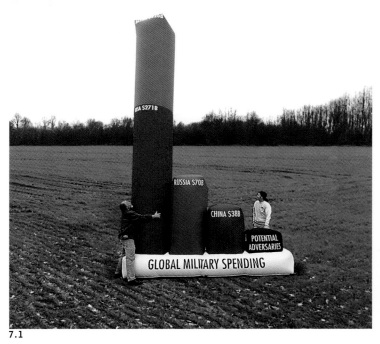

7.1

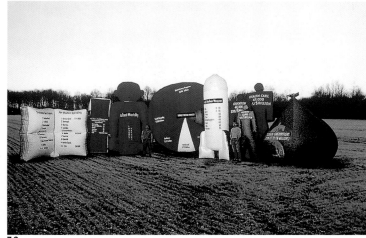

7.2

6 T-SHIRT DESIGNS Sagmeister designed four shirts each illustrating different apsects of military spending. The blue shirt showed the number of jobs created (per $100,000): 2.5 in the military; 5 in healthcare; 4 in education. The green shirt dealt with global military spending, the left bar showing US and NATO spending, the right bar showing everybody else's. The orange shirt showed military spending post-1990, and what happened to the Russian curve (top) and the US curve (bottom). The red shirt showed how Congress spends $1.00 of each person's income tax, the first bar showing the military portion.

7 INFLATABLES The pièce de résistance of the Move Our Money campaign was a range of inflatables; a large three-dimensional interpretation of the initiative's logo baldly illustrating the chunk of military spending alongside the thin slivers representing spending in social areas.

8 GRAPH MUG All the design elements of the campaign focused on the strength of the figures rather than Sagmeister's more usual humorous style. "The numbers were so strong and so surprising (as well as hard to believe) that we thought humor might keep them from being taken seriously. We made every design decision with only one question in mind: Will it work"?

9 DECORATED BUS The Move Our Money bus, covered in dollar bills.

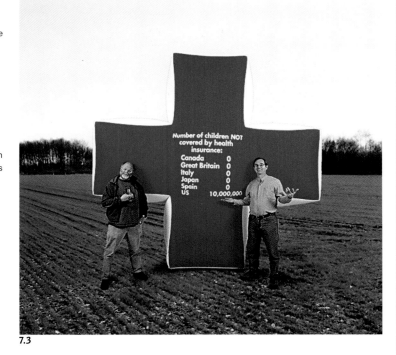

7.3

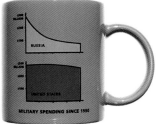

8

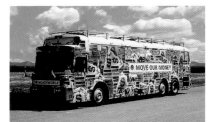

9

Developing strategies

Sagmeister and Cohen set to work on a formal logo for the initiative and witty ways of getting the Move Our Money message across, exploring everything from sketches of people holding hands and rocket humans to pie charts, which eventually became a core part of a range of information graphics. These were delivered on novelties and merchandise, including inflatables, cards, pens, mugs, a folder, a lapel pin, and a bus, the moneymobile, which followed the Presidential campaign around the country. At strategic points (university campuses, country fairs, etc.), the crew set up the inflatables to give a lively presentation, U Slice The Pie, and to distribute the novelties—including pie-chart cookies.

Through 1999 and 2000, the bus provided a hugely effective and memorable way of communicating, as proved by the publicity and excitement it generated. Then September 11 happened and with it, says Sagmeister, "a completely new situation: could you still talk about redirecting money away from the military? Would it do any good?" It quickly became obvious that you couldn't and it wouldn't, which forced a shift in the Move Our Money objectives. They were replaced with "big but achievable goals, though I personally think the 15 percent Pentagon reduction a very valid goal now."

What emerged was TrueMajority, a lobbying group that could air the millions of unheard opinions in US politics. "Most large lobbying groups in the US are right wing or industry-based. The liberal movement is traditionally more grass roots–oriented, which ultimately means that the opinions of the majority of people in the US are not really heard. So we came up with a system that should allow a vast number of people to get involved easily," says Sagmeister.

The system empowers users by keeping them informed and up to date with votes and lobbies, and enabling them to deliver their opinion in a simple and emphatic way to their political representatives. As Sagmeister outlines it, at the heart of TrueMajority is a 10-point program that many people in the US can identify with:

1 Attack worldwide poverty as if our life depends on it. It does.
2 Curb weapon sales to governments that will not even feed their own people.
3 End the nuclear nightmare forever and reaffirm the nuclear missile treaty.
4 Shut the book on Star Wars and cancel Cold War weapons systems.
5 Get real about global warming: sign the Kyoto Accords.
6 End our dependence on Mid-East oil.
7 Pay the UN dues ungrudgingly and end our obstructionism to the world's treaties.
8 Soften the hard fist of globalization against the disenfranchised of the earth.
9 Give "Human Rights" the touchstone status "Anti-Communism" used to have in choosing our friends.
10 Refuse to accept the moral monstrosities of poverty and hunger in the richest country on earth.

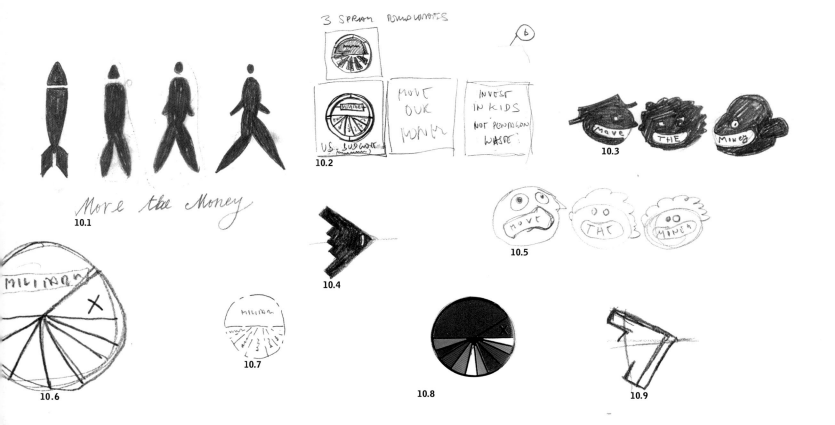

10.1

10.2

10.3

10.4

10.5

10.6

10.7

10.8

10.9

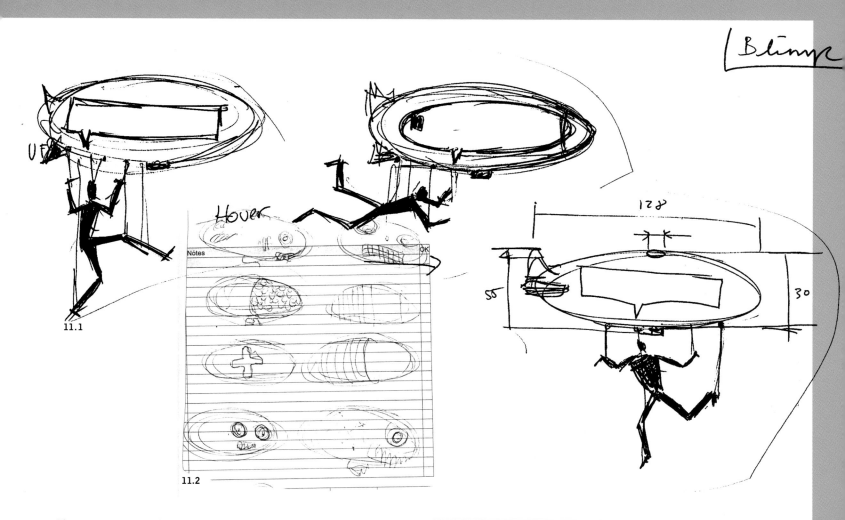

Blimp

Hover

Notes

11.1

11.2

10 WORKING SKETCHES Various loose visuals from early stages of the design development show the pie chart which would become the nearest thing the Move Our Money campaign has to a formal logo.

11 EARLY IDEAS An early casualty of the Move Our Money campaign: "While we were all *very* excited about the idea of the blimp and were already blimp shopping in North Carolina, it turned out that it ultimately was out of our reach budget-wise. Not so much the cost of the blimp itself, but the fact that it required about a dozen people to maintain it," explains Sagmeister.

11.3

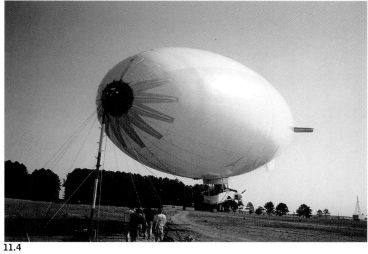

11.4

"I think one of the beauties of our collaboration is that it's been a two-way street."

Mechanisms of action

The system's mechanics are simplicity itself, and based around what Ben Cohen calls "one-click activism". "It's an email service that monitors Congress for issues of justice and sustainability. Twice a month, TrueMajority members receive a short email alert on an important issue pending in Washington. They direct TrueMajority to fax their congressperson, the President, or other important decision-makers on their behalf." And while creating a branding and identity program for this new initiative would prove a headache, it would also prove an instant success; by December 2002, after just five months, the initiative had 75,000 members whose ultimate goal was the fulfillment of as many of the 10 points as possible.

Initial design elements of the project changed radically as it developed. "As in many politically oriented groups, situations, requirements, and goals evolved which called for major directional design changes. The 10-point program was initially the main focus of all our efforts. The group was then called, internally, 'Contract with the Planet,' and we had a complete identity program for it ready to go, then research was conducted, concluding that there was an enormous amount of people supporting our 10 points, which led to the TrueMajority concept," explains Sagmeister. "Obviously, from a design/branding aspect such changes and radical shifts are not fun."

Those shifts made this project more demanding for Sagmeister than any other project he'd worked on. "On so many levels, it's so much more complex. For one thing, you have to be fairly confident that you are right, and this is not a sure thing at all. For example, six months ago I heard a rather convincing talk by a Nobel Prize winner declaring global warming nonexistent and calling it a disaster only

12.1

12.2

12 TRUEMAJORITY LOGO SKETCHES Unlike Move Our Money, the TrueMajority initiative that grew from the first campaign needed a more formal logo that would define its purpose. Through the exploration of different ideas and development of the shapes and colors, the designer moved toward subverting a more traditional representation of the US for the logo.

13 TRUEMAJORITY FINAL LOGO "The image of the national flag in the US is most often used by Republicans and other people leaning towards the right. We wanted to say that if you are patriotic and love this country very much, you are likely to fight for the implementation of the 10 TrueMajority principles. The other visual clues are clear: Lots of people working together to achieve a common goal."

12.3

12.4

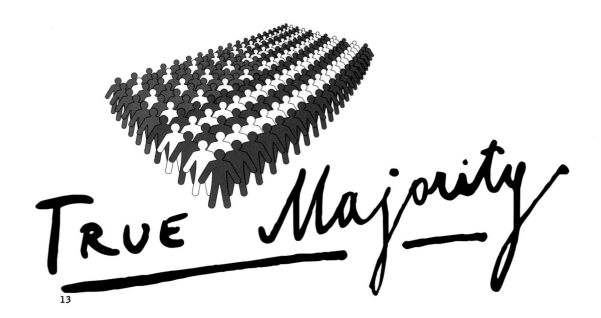

13

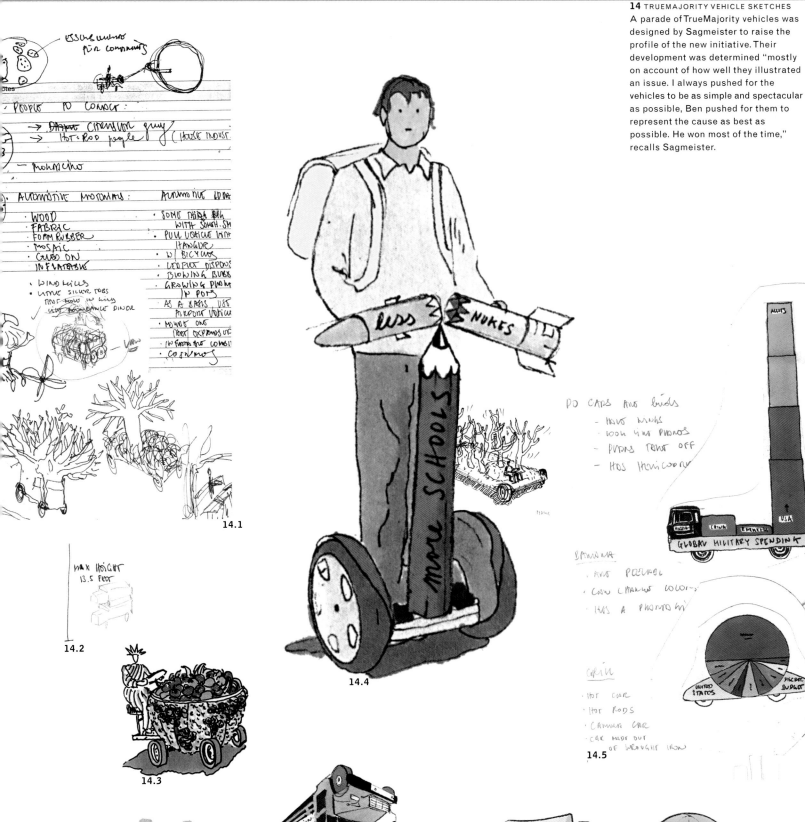

A parade of TrueMajority vehicles was designed by Sagmeister to raise the profile of the new initiative. Their development was determined "mostly on account of how well they illustrated an issue. I always pushed for the vehicles to be as simple and spectacular as possible, Ben pushed for them to represent the cause as best as possible. He won most of the time," recalls Sagmeister.

14.1

14.2

14.3

14.4

14.5

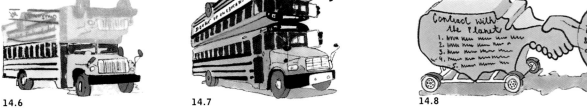

14.6

14.7

14.8

for the scientific community. From a design perspective, this means constant changes in content caused by new research, new policies, and new approaches. On top of that, the reason we got involved was because we thought we'd be able to make a difference. So this stuff has to work. This is much less a concern when you design CD covers, where the need of the effectiveness of a design is rather dubious." Which leads to a final and key question: what is the role of the designer in the twenty-first century? "Questions about content are now at the forefront of graphic design," answers Sagmeister.

Feedback

It's no surprise that the man who gave the world such delicacies as Phish Food ice cream is also the man behind the political lobbying project whose goal was to "make politics meaningful and fun." From the outset, Cohen planned to create an organization that would be "different from the plodding groups that do good work but don't energize everyday people, especially young people who aren't engaged in politics. Through whimsy, we hope our campaign elements break through the clutter of messages to get people's attention and lead them to get active." He is emphatic about the part design plays in that process. "For us, it's the creativity that has bred success, and design is a major manifestation of a creative organization."

Sagmeister and Cohen both say they "clicked" when they met and are equally keen to "learn from each other as learn about communicating on ideas and issues," says Cohen. "I think one of the beauties of our collaboration is that it's been a two-way street."

In his wide experience, Cohen has perceived definite shifts in the designer's ways of working. "If you've got a good designer, there's no problem with the fact that they're now less flexible about their work, less willing to just "change the colors," so to speak. As the impact of design has been more appreciated they are seen more as artists than they were 10 years ago, but that's not a bad thing. Especially if you value design, which I always have," he says emphatically.

15 PIG SKETCHES AND VEHICLES
The pigs, while forming part of the TrueMajority automative stable, still draw attention to the imbalance in Government spending which Move Our Money aimed to change. The largest pig reads "Pentagon budget $396bn," the middle one, "Education budget $34bn," and the tiny one, "Foreign Aid budget $10bn." "Of all the vehicles, they worked by far the best and will probably get the most mileage in the future," says Sagmeister.

16 TRUEMAJORITY VEHICLES
The final parade. A gray Toyota Prius (hybrid gas/electric) has a tree featuring fully inflatable leaves so the tree grows/shrinks before your very eyes. It reads "Reduce our dependence on oil." A yellow truck shows a version of the pie chart. The pig parade highlights military spending. A globe shaking hands with a map of the US reads "Give us two minutes a month, we give you a better world."

Move Our Money design credits:
Art Direction: Stefan Sagmeister
Design: Stefan Sagmeister and Hjalti Karlsson
Client: Business Leaders for Sensible Priorities

TrueMajority design credits:
Concept: Stefan Sagmeister and Ben Cohen
Design: Stefan Sagmeister, Ben Cohen, Matthias Ernstberger, Doris Pesendorfer, and James Riseborough
Car Manufacturing: Turtle Transit
Manufacturing Supervison: Don Sidney

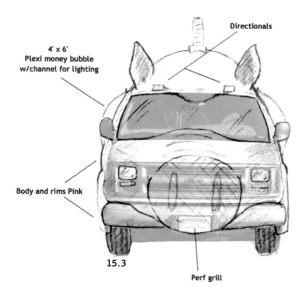

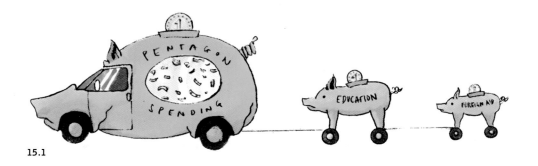

15.1

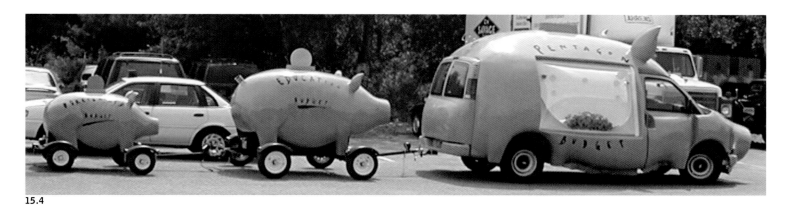

15.4

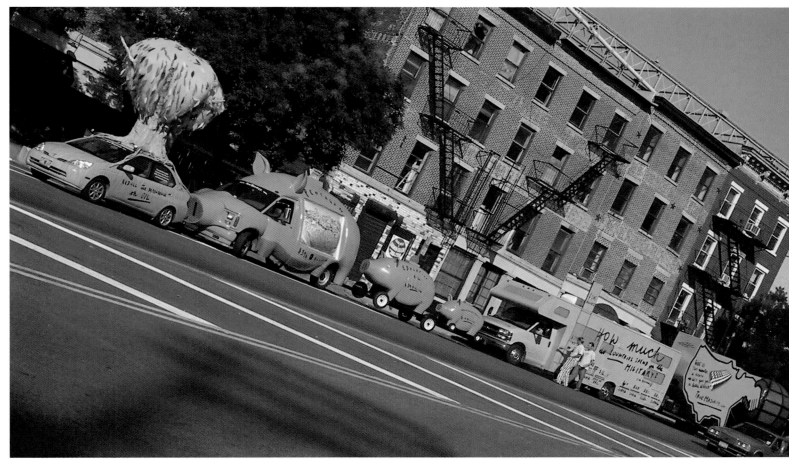

16

S-W-H and Eat
Ecover Rebrand

2

For most of its 20 years, Ecover produced niche household cleaning products, sold to Green consumers in health-food shops. To make a difference to the planet, by getting people to change the chemicals they clean with, Ecover had to take a risk; go global, reinvent the brand, and move into new markets without alienating its core customers or compromising its message.

Company principles

Ecover has been producing ecologically focused washing products since 1979. With its attitude that profits are secondary to respect for people, animals, and the environment, Ecover quickly established itself as a market leader, through sales in health-food shops. For the company, "Ecover" is not just a brand but a principle, and with evangelistic zeal it has been extending its product range and market share by selling in new territories and moving into mainstream retail outlets. This meant increasing manufacturing facilities and Ecover's new factory typically incorporates many ecologically sound features; such as a grass roof, special construction materials, and energy-saving machinery with minimal waste products. Over the years Ecover has won numerous awards, including, among others, Corporate Conscience Award (USA, 1999) and Golden Environment Medallion (Belgium, 1999). So how do you move a brand born in the heady right-on days of the 1970s into the twenty-first century?

Advertising agency Schaeffer Wünsch Has (S-W-H) was founded in 1997 by Lode Schaeffer and Erik Wünsch; a year later they were joined by Mark Aink. Its ethos is to "produce razor-sharp communication for ambitious brands" and its aims are to "activate audiences." Among its clients are various top brands in the Netherlands, including Monster.com, Expedia, Postbank, Dutch Dairy Board, Croky Chips, Bavaria Beer, and Ecover. The design group Eat was formally founded at the beginning of 2003, by Pam Asselbergs, Alex Scholing, and Peter van Deursen. It grew out of a

1

1 NEW BOTTLE CONCEPT An idea that was proposed but is currently on hold due to cost.

2 BEFORE THE REDESIGN Early packaging from Belgium, the US, Germany, and the UK. The design for each country, even the logo, changes.

3 SKETCHES Initial sketches outlining some early conceptual work on the new packaging.

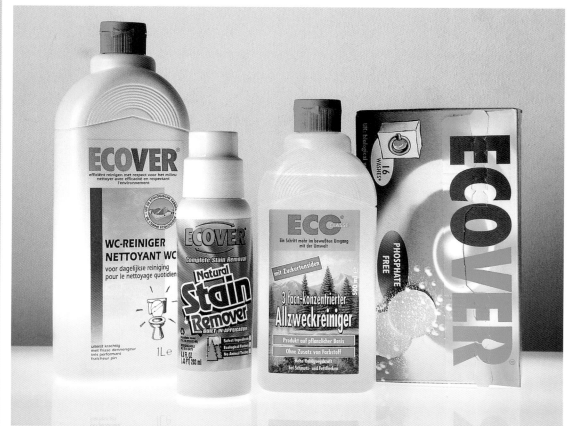

2

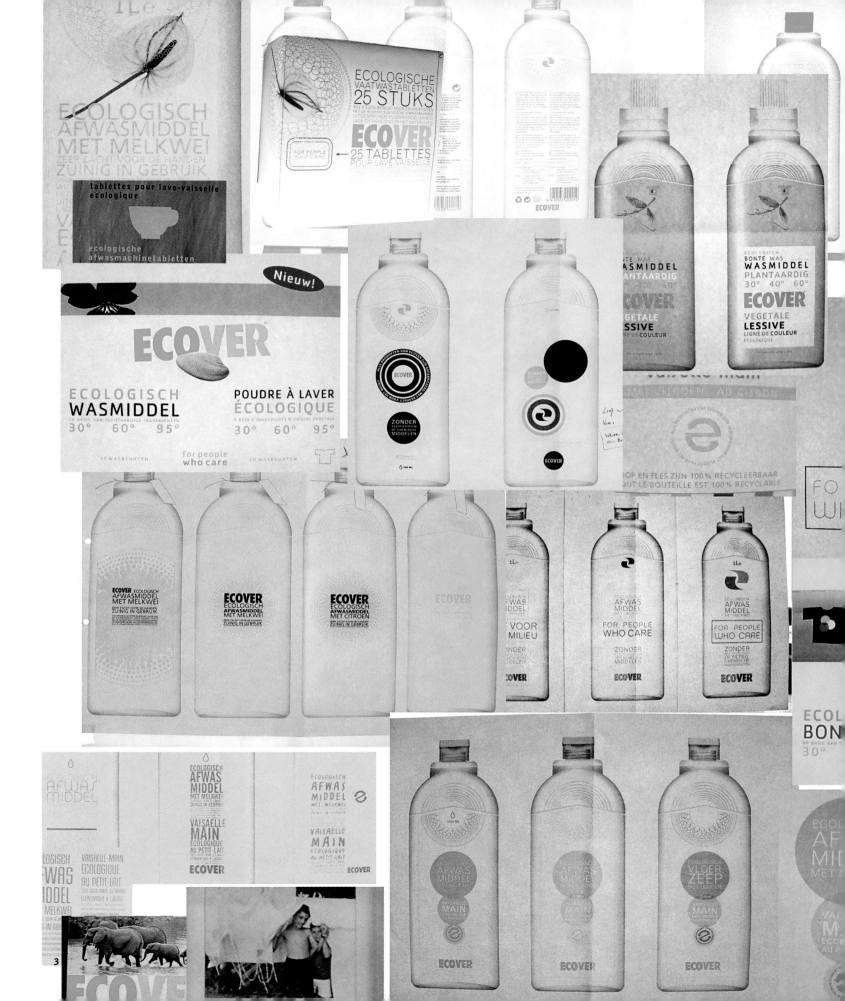

ECOVER

waspoeder poudre à laver

BONTE WAS . LIGNE DE COULEUR

DEZE VERPAKKING IS 100% RECYCLEERBAAR . CET EMBALLAGE EST 100% RECYCLABLE

4

ECOLOGISCH
WASPOEDER
BONTE WAS
GECONCENTREERD
WIJ KIEZEN BEWUST VOOR GRONDSTOFFEN
MET DE HOOGSTE BIOLOGISCHE AFBREEKBAARHEID,
UITGESPROKEN HUIDVRIENDELIJKHEID,
LAGE GIFTIGHEID VOOR HET WATERLEVEN.
POUDRE A LAVER
ECOLOGIQUE
LIGNE DE COULEUR
COMPACTE
NOUS CHOISISSONS CONSCIEMMENT DES MATIÈRES PREMIÈRES
OFFRANT BIODÉGRADABILITÉ MAXIMALE,
DOUCEUR PRONONCÉE POUR LA PEAU,
BASSE TOXICITÉ POUR LA VIE AQUATIQUE.
ECOVER

5

ECOLOGISCHE
VAATWASTABLETTEN
25 STUKS

WIJ KIEZEN BEWUST VOOR GRONDSTOFFEN
MET DE HOOGSTE BIOLOGISCHE AFBREEKBAARHEID,
UITGESPROKEN HUIDVRIENDELIJKHEID,
LAGE GIFTIGHEID VOOR HET WATERLEVEN.

500 g 5 412533 002010

ALLES IS GEFABRICEERD MET RESPECT VOOR HET MILIEU

ECOVER

6

ECOVER

waspoeder poudre à laver

BONTE WAS . LIGNE DE COULEUR

DEZE VERPAKKING IS 100% RECYCLEERBAAR . CET EMBALLAGE EST 100% RECYCLABLE

7

8

collaboration that had existed for years. Ecover is their first client, but all the members of Eat have worked on numerous designs and campaigns individually and collaboratively. "In the past," explains Asselbergs, "we have worked for museums, an airport, a number of ministries, food companies, banks, newspapers, supermarkets, and telecom companies—the works! Not especially companies with strong ethics, though we also designed for nonprofit organizations, like international organizations for the visually impaired, children's aid funds, and a correctional institute for juveniles."

Tailoring the strategy

S-W-H's and Eat's involvement with Ecover began with a chance meeting. Xander Meijer had just joined Ecover as Marketing and Sales Director. "Mark Aink met Xander Meijer at a party," relates Asselbergs. "Xander asked Mark about his dreams and Mark described his ambition of making meaningful, high-standard brands so popular that they could change an entire industry." As Xander had just joined one of these companies, he invited S-W-H to their factory in Belgium and asked the agency to develop an advertisement for retail magazines, because they wanted to expand distribution into regular supermarkets. S-W-H advised Ecover to change their packaging to be something a consumer would want to take home and display, the idea being that this was free publicity and endorsement. Through S-W-H, the group that was to form Eat became involved in the design of a new brand identity for Ecover. "The problem was how to streamline the various design styles that were currently being used worldwide, how to appeal to a new type of consumer, and how to challenge the new competition." Adding values such as gentle and green to established brands was becoming a trend. Ecover, holding these values as core concepts in its whole enterprise, had the opportunity to expand its markets; not doing so was to risk being squeezed out of the market.

4 ANIMALS "The animals, although they said natural and environmentally friendly, appealed more to our 'dark green' and less to the new 'light green' customers," explains Ludo Martens, Product Manager with Ecover.

5 TYPOGRAPHIC SOLUTION "Typographical packaging with some pale photographs was turned down because it looked too much like a cheap house brand," explains Asselbergs of Eat.

6 ALTERNATIVE TYPOGRAPHIC SOLUTION Another option using typography as a design element, with flower images to suggest nature and bubbles to suggest cleaning.

7 WHITE STRIPES White stripes injected into translucent plastic to suggest cleanliness. Clean washing shown against the skin of children was to emphasize both the cleaning power and kindness of the product.

8 COLORED STRIPES Color injected into translucent plastic for maximum display impact. "The redesign using stripes on a transparent bottle was technically too difficult to produce."

9 COLORED TEXTURES Colored textures suggesting basic elements (earth, water, and sky) and an (e) symbol to suggest the ecological.

9

10

"In talking to Ecover, it became obvious that they needed to deal with changing world attitudes; environmental issues were becoming mainstream."

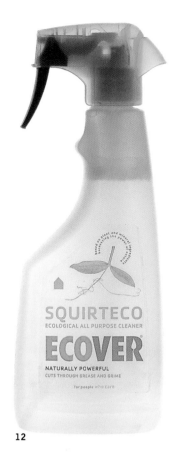

11

12

“In talking to Ecover,” continues Asselbergs, “it became obvious that they needed to deal with changing world attitudes; environmental issues were becoming mainstream. This meant their clientele was changing, and it was our task to adjust the brand to these changes. We visited health stores in the US and UK to study eco-products and also to look into regular detergents at supermarkets, with the usual research into display methods. However, before redesigning the packaging, we needed a strategy. The new breed of consumer wanted both performance and a green conscience, without compromising on either. Ecover is not a marketing fad or even a brand; it's a movement. They will do anything to find ways of inventing and producing environmentally sound products in an ethical manner and be a beacon of inspiration within the industry in order to make the industry change.” S-W-H and Ecover compiled a list of core values and actions: pioneer, care, inspire, challenge, genuine, commitment, and action. It was unanimous that Ecover's strongest virtue was their integrity, and it was this they needed to communicate.

With the core values and strategy established, the practicalities had to be faced. “The budget was a massive constraint,” explains Asselberg. “For instance, our first suggestion, to use discarded bottles of other brands to save on plastic, was rejected; it would have cost twice the budget to adapt the filling machines. Our next suggestion, to use existing milk cartons, was abandoned because of the aluminum lining, which is an ecological nightmare. In the end we had to accept the existing bottles. Even our suggestion to remove the embossed rainbow would have cost half the budget. This was actually the hardest concession we had to make. We suggested eliminating the color in the bottle hull, which was white. Ecover was

10 WASHING-TABLET PACKETS Various recyclable materials were considered for the redesign, including foil and polyethylene. However, customers perceived cardboard as being more ecologically friendly packaging. The cardboard used is 95 percent recycled.

11 WASHING-UP LIQUID “Two of the core values of the brand are honesty and transparency,” says Ludo Martens. “That is why we use transparent bottles to show our product and let people know that we have nothing to hide. The bottles themselves are fully recyclable. We always combine materials which can be recycled together. So our bottles do not have paper labels …”

12 ALL-PURPOSE CLEANER Ecover rejected typographically heavy solutions; they wanted a pictorial notion of “green nature” incorporated into the design. “After searching, we eventually found the lathyrus leaf, which is both a vegetable and a flower, and grows very fast. This is symbolic of versatility and strength,” says Asselbergs.

13 US WASHING-POWDER PACKETS “For the US market, it was felt that the UK design missed efficacy cues and reassurances of the brand. We placed our three unique selling points on the front rather than the back, and added more color,” explains Ludo Martens.

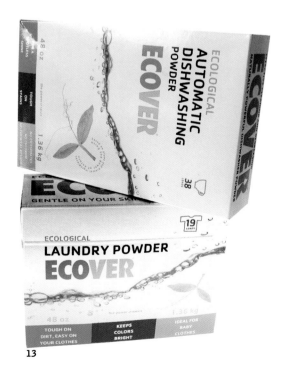

13

against a fully transparent bottle because they feared the contents would be unappealing, however, we convinced them that this would show their integrity and emphasize the ecological nature of their product." They concentrated on one important ecological concern; to use as little ink as possible in the entire process and to stay away from metallic and fluorescent inks. "We did not incorporate any full-color fields, but instead opted for a typographic solution. We had the use of a six-color flexo-press, so we did indulge in using six different colors. We opted for bolder colors to eliminate the daft image of olive green and terracotta red and other traditional eco-signifiers."

They also color-coded the bottle caps for functionality. The plastic for the label, bottle, and cap are 100 percent recyclable, which is clearly mentioned on the back label, and the carton box is made from 95 percent recycled cardboard. All packaging also mentions that Ecover was elected to the Roll of Honour of the United Nations Environment Programme in recognition of their exceptional practical achievements for the protection and improvement of our environment.

Inspiration

Inspiration for the redesign came from a bottle of peppermint oil and a box of chocolates. "Years ago," confesses Asselbergs, "I found this great bottle of peppermint oil in New York. It was a plastic bottle with a dark blue label, crammed with all-over text about all the things you could do with it ... Strangely, this hardly legible text invited you to read the whole thing. For the typeface we found a box of chocolates and the font Cachet was pretty close to what we aimed for." Although the Ecover logo had recently been redesigned they decided to change the dark blue and green colors into brighter Pantone ones. The idea was to keep the labels purely typographical, without any symbolism or mood imagery, but Ecover insisted on incorporating some notion of "green nature." Eventually, after exploring various imagery, everyone settled on a lathyrus leaf, which is a pea and a flower and grows very fast, as a signifier for nature. They also decided on a single design for worldwide use, with one exception—the US market, which was Ecover's second largest. After research, the subtleties of the European packaging were made bolder and more up front.

14.1

14.2

14 PACKAGING *IN SITU* One aim of the redesign was to produce packaging that people would be happy to leave on show around the home, the idea being that personal endorsement is a powerful advertising tool.

15 PACKAGING ON DISPLAY IN SUPERMARKETS In moving from niche sales outlets into mainstream supermarkets, the new packaging had to compete with established brands. It needed to stand out and convey Ecover's unique ideas while at the same time reassuring consumers.

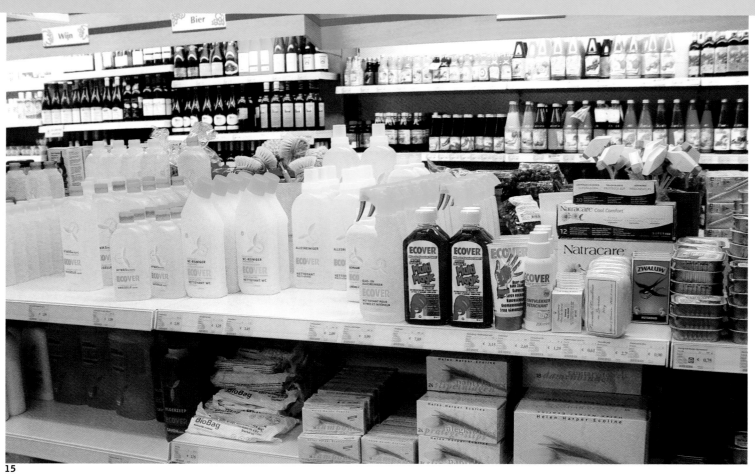

15

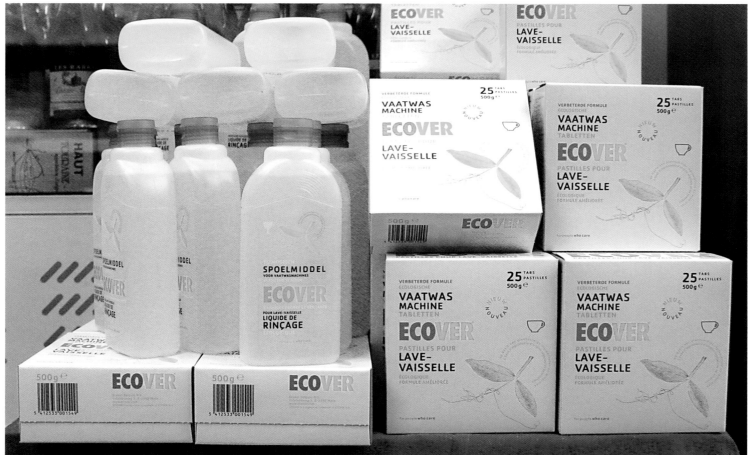

15.1

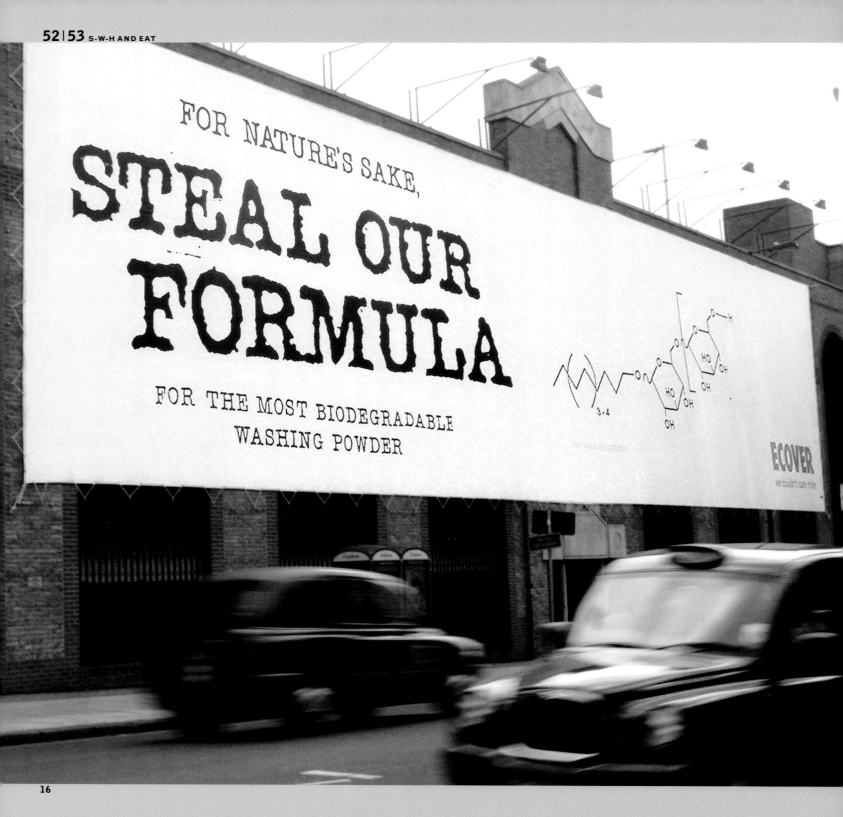

16

"It was a calculated risk since competitors could have used our work to make a rival product and squeeze us out of the market."

Sorting out the logo and packaging and getting the product onto shelves is only half the story; getting them off the shelves is the other half. Based around Ecover's values, S-W-H embarked on a campaign for the UK which took a revolutionary approach—Steal Our Formula! As Asselberg's explains, "They took the core values of 'integrity' and 'pioneer' as the basis for the campaign. Around the theme of We Couldn't Care More, they made the ultimate gesture and revealed Ecover's secret formula." On giant street posters, at bus stops, and in subway stations, Ecover's most precious commodity was publicized—the chemical formula for their washing powders. Throughout London it was printed on T-shirts left hanging on washing lines. Brilliantly simple and bold, the campaign was boosted by exposure and debate throughout the media. Imagine if the Coca-Cola recipe was printed on their cans and consumers invited to make their own! It is hard to think of any other campaign or company that's prepared to put its money where its mouth is, but then Ecover is not just another company. S-W-H and Eat's work has contributed to Ecover's ambitions to preserve the planet by changing an entire industry and consumers' attitudes.

Feedback

"The Steal Our Formula campaign was part of our policy of openness. It was a calculated risk since competitors could have used our work to make a rival product and squeeze us out of the market, but we didn't think that would happen. Essentially, our product is based on plants and minerals, natural substances, and theirs are petrochemical based. It would be very difficult for them to change their manufacturing techniques, plus, if they did, it would make a negative public statement about the petrochemical industry. However, if people can use our work and it helps the environment then we are happy," explains Ludo Martens, Product Manager at Ecover.

"Since the redesign our turnover has increased somewhere in the range of 10 to 20 percent. Our product range has been growing since the introduction of the new design; for example, we will be introducing a stain remover to the UK market, based on plant and mineral ingredients. We also plan to extend distribution and grow throughout 2003. The new design and campaign has been very important in bringing more and more people into the Ecover concept and at the end of line, nature will also profit from this."

16 STEAL OUR FORMULA BILLBOARD
Ecover's formula for washing powder was revealed on huge posters, in subways, at bus stops, on balloons, and even on T-shirts hanging on washing lines, which the public was invited to steal. The boldness of the campaign led to even bigger exposure through media coverage.

17 STEAL OUR FORMULA BALLOONS
As Ludo Martens explains, it was "a calculated risk that competitors might use our work to make a rival product. However, if people can use our work and it helps the environment then we are happy."

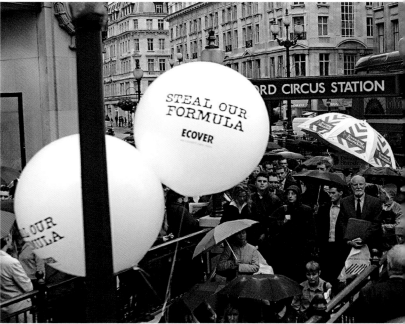

Flat Inc.
Public Service
Announcements

Flat's focus is on making information accessible, concentrating on the user experience and the integration of technology into daily life. Its areas of expertise include interactive design, graphic design, and content development. In winter 2000 it launched the first in a series of on-line public service announcements as an experiment to visualize a new look for the New Left in the US.

Social concerns

For Flat, the key to great design is the right mix of people. Tsia Carson, interactive designer and Art Director at Flat, is a lecturer at Yale and an Adjunct Professor at the University of the Arts in Philadelphia. She is also on the Board of the New York Chapter of the AIGA. Doug Lloyd, Creative Director, is also a lecturer at Yale, and together with founding partner Carson, was profiled in 2000 in *I.D.* magazine's 40 influential designers under 30 years old list, "40 under 30." Petter Ringbom, who grew up in Sweden, served as Art Director for *Sweden & America* magazine. He created a new corporate identity for New York's Bellevue Hospital, and while working with Utero, designed an interactive game for live television that continues to be broadcast on a daily basis.

Much of Flat's output incorporates social issues, and it has done a lot of work for nonprofit organizations. The Bronx Museum of the Arts serves the culturally diverse populations of New York and encourages participation in contemporary arts. Flat developed the museum's website, including interactive information systems, and signage. Other clients include the Bellevue Hospital and the New York City Marathon. In Flat's growing portfolio of politically progressive projects is buyingtime.org. As part of The Brennan Center for Justice's campaign for finance reform, Flat designed the book *Buying Time 2000* and the acclaimed 1999 website *Buying Time*. Both were created to give the public access to hard numbers concerning political advertising spending.

Flat's politics and humor have informed its ethos and output. "The New Left is heterogeneous and that's what we're hoping to reflect with our work," says Lloyd. Flat is acutely aware of the social responsibility of the designer. "Every designed object is in part social. Whether it's a laser-guided missile, a genetically designed seed, a voting ballot, or a book for children," explains Carson. "While the design community tends to value formal attributes above all else, the rest of the world knows that if the social consequence of the

1

1 BANNER FOR THE NEW YORK CITY MARATHON Much of Flat's output incorporates social issues and work for nonprofit organizations.

2 INFLUENCES: SCHOOLHOUSE ROCK This was a seminal US children's TV series in the 1970s. It explained mathematics, home management, science, grammar, and the US political system through cartoon and song.

3 INFLUENCES: BLACK PANTHER PARTY GRAPHICS Well known for its use of activism and protest as a political tool during the 1960s, as part of a wider movement for black equality, the Black Panther Party used a range of graphic materials to promote its cause.

2.1

2.2

THE BLACK PANTHER

25 cents

Black Community News Service

VOL. III NO. 25 SATURDAY, OCTOBER 11, 1969

PUBLISHED
WEEKLY **THE BLACK PANTHER PARTY** MINISTRY OF INFORMATION
BOX 2967, CUSTOM HOUSE
SAN FRANCISCO, CA 94126

OAKLAND 1968 FASCISM CHICAGO 1969

object is not considered by the designer then it's bad design. In the end, designers take responsibility by suffering the consequences like everyone else. Rather than passively conform to expectations, we wish people would be braver about using what little agency they have to not only change things in grand, heroic ways but also to muck things up on a daily basis for the betterment of us all."

Public experiments

Flrt.com is one of Flat's "home-brew projects" and a place to house its popular psa series, a biased and sardonic twist on the traditionally "impartial" Public Service Announcement. The psa series was an experiment by Flat to see how the internet could be used to critical effect and to demonstrate how design could revitalize the Left. The Flash-format projects, featuring animation and interaction, bring a political edge back into design. It took a year before all the threads could be woven into a fabric that everyone at Flat felt happy with. They began by exploring the intersection of social issues with technology. There was no brief or commission; the final pieces were arrived at through collective effort, group consensus, and open discussion. However, there was one exception: after doing a number of psas, Flat was commissioned by the AIGA to create one on the role of design for its biannual National Design Conference.

Influences

Flat mulled over a wide variety of work from the Zapatistas to Allen Lane, father of the paperback. "I'd love to walk a bit in Allen Lane's footsteps; to couple popularizing intelligence with a strong visual presence," says Carson. "The Internet has been very successful as a communication tool for the New Left. We want to resurrect the grand graphic tradition of the Left. We believe it got buried in a time

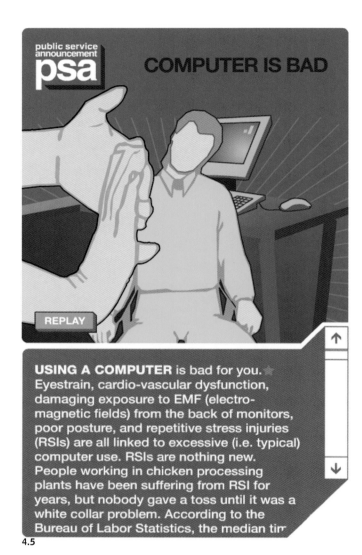

4.5

4.1

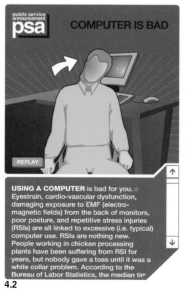

4.2

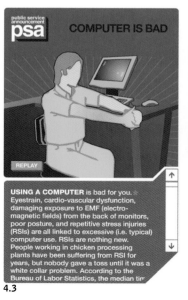

4.3

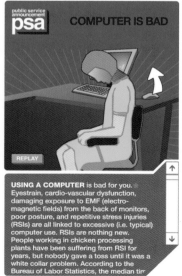

4.4

4 COMPUTER IS BAD, SUMMER 2001
"Basically all of us at Flat suffer from some form of repetitive stress injury. So we did some research. This is our most utilitarian psa and we got a lot of happy email about it from people who evidently didn't know how to stretch," explains Tsia Carson.

5 FLRT HOME PAGE
"On Flrt we are nastier, looser in our approach to the detriment of necessarily reaching a wide audience," explains Carson.

6 ONE PERSON, TWO VOTES, INAUGURATION 2001
"We actually started this way before the whole presidential vote fiasco in 2000," explains Lloyd. "The one person=one vote is just absurd now that we have computers that can calculate more complex voting systems. It's impossible to vote for a third-party candidate in the US without being yelled at for throwing your vote away."

5

6.1

6.2

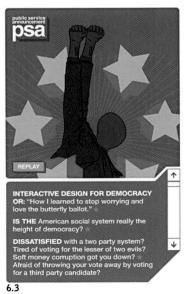

6.3

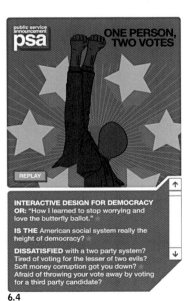

6.4

7 WHAT DO THE TREES WANT?, WINTER 2000 "We didn't want to send out more corny Christmas cards. It got sparked by some comment we heard about how trees wanted to be chopped down to be put in Rockefeller Center in NYC. We started to look into the Christmas-tree industry. We realized it was a red herring and that the true environmental threat was happening via the lumber industry lobbying groups getting the government to permit logging on federal land," explains Carson.

7.1

7.2

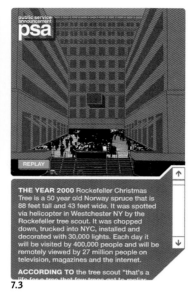

7.3

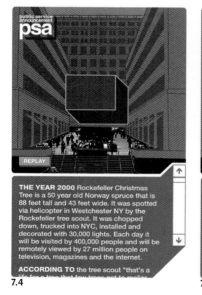

7.4

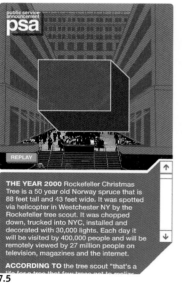

7.5

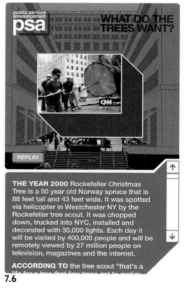

7.6

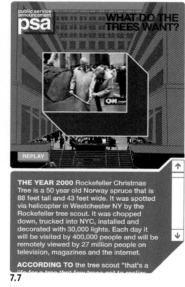

7.7

"Every designed job is in part social. Whether it's a laser-guided missile, a genetically designed seed, a voting ballot, or a book for children."

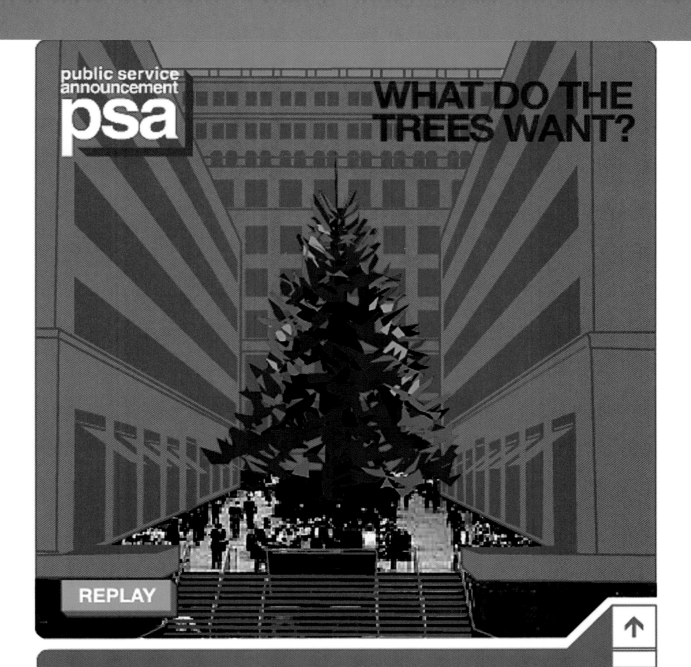

REPLAY

THE YEAR 2000 Rockefeller Christmas Tree is a 50 year old Norway spruce that is 88 feet tall and 43 feet wide. It was spotted via helicopter in Westchester NY by the Rockefeller tree scout. It was chopped down, trucked into NYC, installed and decorated with 30,000 lights. Each day it will be visited by 400,000 people and will be remotely viewed by 27 million people on television, magazines and the internet.

ACCORDING TO the tree scout "that's a

7.8

8.1

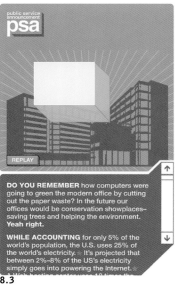

8.2

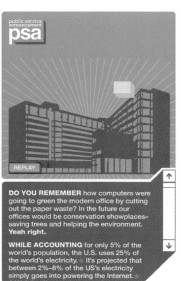

8.3

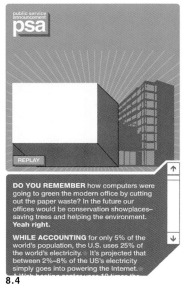

8.4

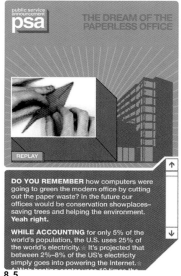

8.5

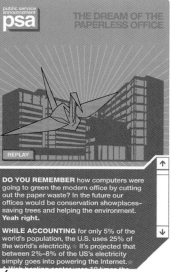

8.6

8 THE PAPERLESS OFFICE In order to demonstrate the value of energy conservation and efficiency, Flat has included links; EcoISP, US Congress, Congress of World Energy Council, and even CNN. This takes the debate beyond the arguments laid out in the psa, informing and educating users.

9 WHAT IS DESIGN GOOD FOR ANYWAY?, FALL 2001 The AIGA-commissioned psa, which considered the role of design and social issues. Flat felt that people often misunderstood and undervalued design and that designers were conflicted as to whether to aspire to be a "pure" communication channel or a critical voice with their work. They tried to open the conversation.

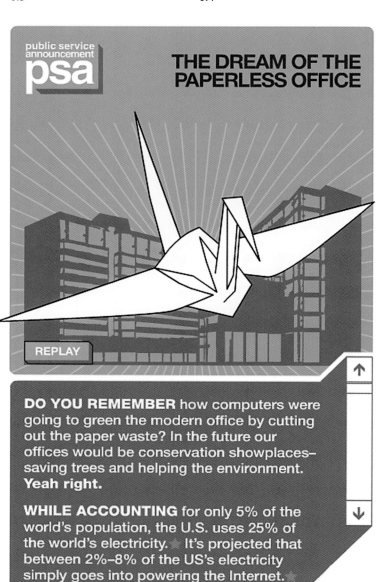

8.7

capsule c. 1979." To date, Flat's "smart-mouthed" psas cover topics such as energy conservation, ergonomics, voting reform, and the value of design. Designed to exist on-line, and originating from on-line investigations, each psa not only gives a succinct and visual explanation of an argument, but also offers multiple links for the user's continued exploration. Politically acute, each presents its polemic in a simple manner that opens up complex subjects to everyone. "They're very white-collar, Western worker," explains Carson. "However, unlike our other work, Flrt is really an experiment with design and our personal interests; it's for peers mainly. In our client work we are very generous and open in the way that we create meaning with the audiences we are trying to reach. On Flrt we are nastier, looser in our approach to the detriment of necessarily reaching a wide audience."

The psas are informed through a combination of Schoolhouse Rock with a Black Panther aesthetic. Schoolhouse Rock was a series of influential animated educational shorts that went out to a US national audience as part of the Saturday morning children's TV programming in the 1970s. Featuring cute characters and catchy songs, these little films covered everything from multiplication tables to grammar, from money to Congress. As part of its political struggle for reform in the 1960s, the Black Panther Party produced a regular newspaper. "The Black Panther stuff is just straight-up beautiful," enthuses Carson. "No budget, no bull, and they were kicking out these newspapers every week. A lot of our work is about depth and contradiction. We hope that this can breathe life back into ideas that have been collapsed into caricature, like being radical or populist."

Feedback

Alice Twemlow, Editor and Program Advisor for the AIGA, recalls how she first came across Flat. "Someone had forwarded me an email with a link to an animated psa about recycling Christmas trees and I thought it was brilliant. Not only because it was a novel Christmas message that didn't waste any trees in the telling, but also because it furthered a useful environmental cause. It was fun, it didn't preach, it merely questioned. It looked cool too, and interesting. You could mine links for deeper levels of information."

Consequently, Twemlow commissioned Flat. "I remember Flat sending me simple-to-read flow charts that I could edit by hand and fax back to them. Lovely and low-tech. The use of sound in this psa really helped increase the accessibility of the content. Pings and whirs associated with a pinball machine accompanied the user's journey through the questions, elevating the potentially 'heavy' material to the level of play. Flat were entirely responsible for the content of the psa. We chipped in the odd comment and suggestion here and there, and found some cool links, but the project was motivated by Flat. What is particularly good about Flat is the way they develop and maintain a consistent tone for their work; it's a bit cheeky, a bit funny, but mostly honest and direct."

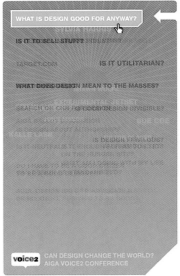

9.1

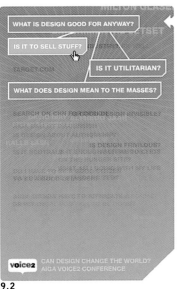

9.2

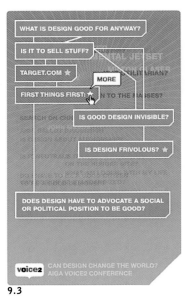

9.3

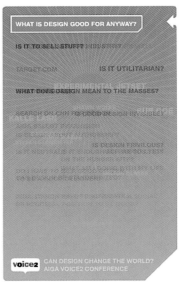

9.4

Modern Dog Design Co.

AmphetaZINE

4

In business since 1987, Modern Dog's client base included various commercial companies and nonprofit organizations. In 1999, an old client approached them with a brief; redesign an HIV prevention booklet, get the target group to read it, educate them, and save lives.

Recognition and success

Founded by Michael Strassburger and Robynne Raye, Modern Dog Design Co. conceptualized and executed a wide range of advertising, product development projects, and campaigns in its first 10 years. These included snowboard designs, ads, brochures, corporate identity, and packaging which contributed to the fledgling K2 snowboard division becoming a major competitor within the industry. Their client list grew to include Seattle's King County Health Department, Henry Art Gallery, Tacoma Art Museum, Swatch, UNI-QLO, Simon & Schuster, the Yale Repertory Theatre, and Seattle Repertory Theatre, among many others. Along with television graphics for Nissan, they produced packaging design for RCA Records, Warner Bros. Records, and MCA Records. Modern Dog's work has been recognized and featured in many major design magazines—*Matiz* (Mexico); *HAUTE* (Korea); *IDEA* (Japan); and *Step-by-Step* (now *Step Inside Design*; United States). Their work has been accepted into the permanent archives of the Denver Art Museum, the Smithsonian Institute's Cooper-Hewitt National Design Museum, and the Library of Congress, and exhibited around the world. On top of all that Strassburger and Raye also teach design at Seattle's Cornish College of the Arts.

The commission

In 1999, an ex-client contacted Modern Dog. The client had begun work for Seattle-based Needle and Sex Education Outreach Network (NEON), and wanted Modern Dog to redesign their HIV prevention booklet, *AmphetaZINE*, produced for Seattle's gay and bisexual crystal methamphetamine users. Crystal meth enhances libido and reduces an individual's judgment regarding risk behavior. Its use is associated with increased rates of unprotected anal sex, and a large rise in numbers of sexual partners, with intensified and extended sexual encounters. With increasing rates of new HIV infections among this population, properly targeted HIV and STD education was vital to try and prevent further spread.

"The *AmphetaZINE* brochures were not being picked up or read by the target population," explains Raye, "so we were brought on board. " The "zine" format was used because it had a homegrown feel, appealing to users where traditional health pamphlets failed. "Articles are based on principles of harm reduction, health promotion, and withheld judgment. *AmphetaZINE* seeks to stop the further spread of HIV and improve health status by empowering gay and bisexual crystal users to take better care of themselves and their community." The project had a next-to-nothing budget, which drove the look and feel.

1 SPREAD, ISSUE 18 Although *AmphetaZINE* is printed off-set, it is designed to be photocopied, allowing peer educators and readers to copy and pass on articles. This means using high-contrast images and coarse halftones for fidelity when copying.

2 *AMPHETAZINE* 20TH ISSUE *AmphetaZINE*, an HIV-prevention booklet, talks to crystal meth users without preaching. The fact that crystal meth users have been shown to adapt their behavior in some areas signals that they could respond to targeted HIV and STD prevention and education messages.

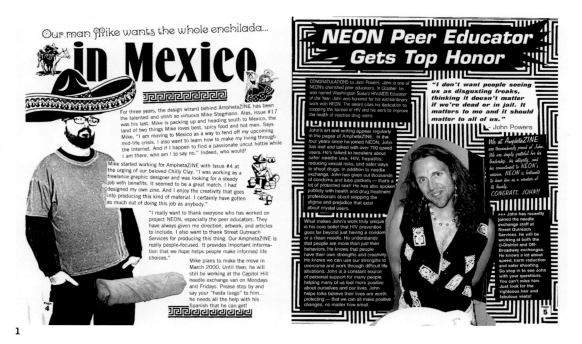

1

"If people aren't pulled into the piece, if something doesn't catch their eye, then it doesn't matter what I've written because no one is reading it."

August 2000 and — as always — absolutely FREE!

Best of AMPHETAZINE

Celebrating 5 years of Seattle's favorite crystal-meth zine!

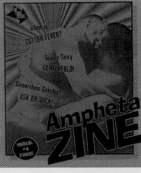
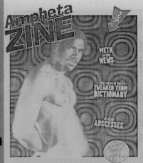

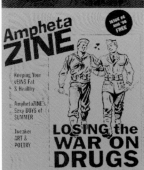
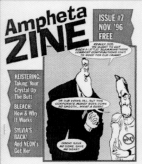
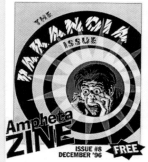
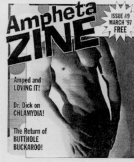
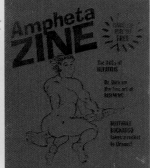

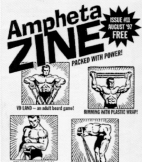
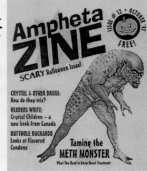

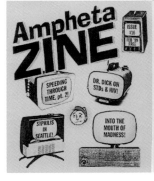
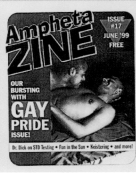
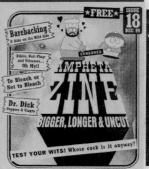
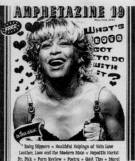

Number 20

4

The design approach

Initially, Modern Dog had no idea what to do. James Fisher, from NEON, gathered feedback directly from the community. "We really learned quite a bit through that early process. This is a group that tends to hide in the background. They are often discriminated against, even within the injection drug—using community. Rehabs often turn them away because of the low success rate within this group. We heard firsthand accounts of the effects of the addiction on their friends and loved ones. If they could stop, they surely would. I think it's really difficult for someone who's never been addicted to anything to really understand. It made us feel good to help."

Modern Dog's redesign adopted a very up-front style, a mixture of punk and camp, a visual blend of frankness with humor. Explains Raye, humor "is a great way to help defuse the harshness of the subject matter." It is harder for people on meth to keep focused on reading, "so we kept everything at or below a fifth-grade reading level. Also, we divided up much of the information into bite-sized chunks that were easy to comprehend out of context if someone was just skimming. One really great way to do that is through advertising parodies. Not only are they intriguing and entertaining, we really believe the readers will have a much easier time retaining the information." But they had to walk the delicate line between making *AmphetaZINE* entertaining and fun, and making drug use look fun.

According to Raye, the inspiration for the project came from the compassion of Michael Strassburger. "He's one of the most accepting people I've ever met. He has a real love for humanity. When I look at *AmphetaZINE*, his humor and love come pouring out. He has this amazing ability to make people feel at ease with themselves. I think it's why this project is so successful."

3 SPREAD, ISSUE 25 Crystal meth users really get into all of the small details, which is why Modern Dog included puzzles, games, and hidden sex jokes.

4 SPREAD, ISSUE 18 Avoiding the victimizing tone of much antidrug campaigning, *AmphetaZINE* doesn't patronize or overload with statistics.

5 SPREAD, ISSUE 21 Through parodies of ads, readers can be brought in quickly, and issues and information presented as entertainment.

6 SPREAD, ISSUE 20 People "tweaking" on crystal meth have a limited attention span, so information is divided up into chunks that are easy to comprehend out of context.

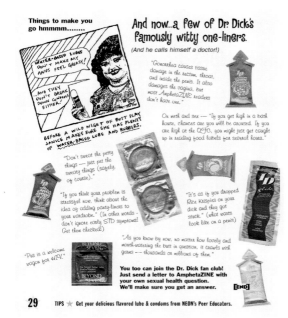

5 6

PUS IS BAD!

~ Get the Pus Out!

Need help getting the pus out of those nasty little abscesses?

Well, get your butt down to the new Medical Clinic at the Downtown Needle Exchange.

Not only can they help get rid of the **pus** — they can also help with a whole bunch of other health problems. Jim Paul () and Yvonne Marquis () are the two medical providers. They have a lot of medical experience and strongly believe in providing respectful medical care to everyone — including people who use injection drugs.

Jim has been a Physician Assistant for 12 years since graduating from the University of Washington. He has been taking care of people in the downtown area for the past 8 years. He has a lot of experience treating abscesses and other kinds of infections.

Yvonne has been a nurse practitioner for the past 6 years. She has a kind ear and enjoys the many and varied stories she hears from those she treats. Yvonne enjoys working at the Downtown Needle Exchange Medical Clinic because she can provide needed health care services in a comfortable and non-judgmental environment.

Jim () and **Yvonne** () recently were visited by one of San Francisco's finest abscess specialists. He gave **Jim** () and **Yvonne** () pointers on the best ways to treat abscesses. Most uncomplictaed abscesses can be drained with a small incision. In the majority of cases, abscess care can be nearly painless. In fact,

pain free treatment should be the goal of anyone who treats an abscess ■ !

6

(cont'd on next page)

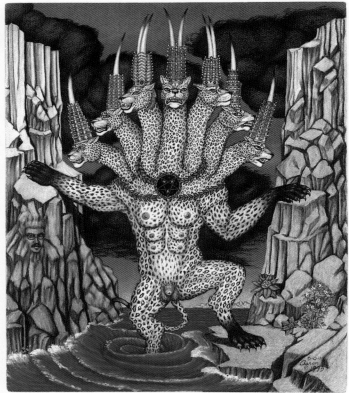

REVELATION 12:4, 7-9

REVELATION 13:1-3, 18

8

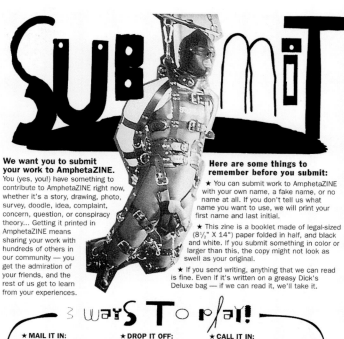

We want you to submit your work to AmphetaZINE.
You (yes, you!) have something to contribute to AmphetaZINE right now, whether it's a story, drawing, photo, survey, doodle, idea, complaint, concern, question, or conspiracy theory... Getting it printed in AmphetaZINE means sharing your work with hundreds of others in our community — you get the admiration of your friends, and the rest of us get to learn from your experiences.

Here are some things to remember before you submit:

★ You can submit work to AmphetaZINE with your own name, a fake name, or no name at all. If you don't tell us what name you want to use, we will print your first name and last initial.

★ This zine is a booklet made of legal-sized (8½" X 14") paper folded in half, and black and white. If you submit something in color or larger than this, the copy might not look as swell as your original.

★ If you send writing, anything that we can read is fine. Even if it's written on a greasy Dick's Deluxe bag — if we can read it, we'll take it.

3 wayS To play!

★ **MAIL IT IN:**
AmphetaZINE
1122 East Pike #109
Seattle, WA 98122-3934

★ **DROP IT OFF:**
At the Capitol Hill Needle Exchange.
Mon. & Fri., 5:30-8pm.

★ **CALL IT IN:**
Call in your ideas, questions, comments and complaints to James at 622-6925

/////////////// **THINGS WE ABSOLUTELY WILL NOT PRINT** \\\\\\\\\\\\\\\
We won't print the real names of people other than the author (and only the author's name if he/she specifically requests it). We won't print articles that are misleading or harmful. We won't print writing or art that we feel promotes unprotected anal sex, needle sharing, kiddie porn, or the heterosexual agenda. Other than that, it's pretty much fair game.

9

7 SPREAD, ISSUE 18 (previous page)
The topic of HIV is often considered by gay and bisexual men as either too heavy or completely irrelevant. Through its offbeat approach to the subject, *AmphetaZINE* avoids both, while continually reinventing messages about HIV and sexual health that keep these topics fresh.

8 SPREAD, ARTWORK BY ED AARON
Although the content was usually decided upon by the staff at NEON and Stonewall Recovery Services, *AmphetaZINE*'s readers were also asked to contribute to the magazine. This created an inclusive community and gave readers the opportunity to expose their talents.

9 REQUEST FOR WORK, ISSUE 21
Invitation for submissions, *AmphetaZINE* style.

10 SPREAD, ISSUE 18 In *AmphetaZINE*, humor defused the harshness of the subject matter. Taking its look from 'zine subculture, its style is akin to camp punk.

Content and distribution

The content is decided upon by the staff at NEON. Readers write in with feedback and suggest topics themselves. Poetry, articles, and original artwork are also contributed by members of the target audience, creating a sense of community by inclusion. Modern Dog took all of that on board in their designs. They knew that the target audience would be looking at the 'zine while on drugs, 'tweaking'. As *AmphetaZINE*'s resident health-care expert Dr. Dick says, "If you get high in a bathhouse, chances are you will be aroused. If you get high at the supermarket, you might just get caught up in reading food labels for several hours!" "Tweakers look at everything," explains Raye, "and really get into all of the small details. That's why we've included a lot of puzzles, games, and hidden sex jokes."

"Our readers love the blend of humor, sexual imagery, and cultural reference that really is their own, and we have a very committed readership!"

Upon the urging of AmphetaZINE, my boy friend Sweetpea and I went to our favorite sex toy supplier, Toys in Babeland. We were looking to add a little variety to our already exciting sex life. We were blown away by the wide variety of toys available today.

Gone are the days when your only choices were a few tired dildos, cock-rings or Mr. John the blow-up sex doll. Basically, in the land of sex toys, if you have an "itch," Toys in Babeland can scratch it or plug it! Because of the wide variety of sex toys available, I am just going to talk about our "dildo experience."

You might ask, why am I professing the delights of dildos? Well, there are many great things about them. They are always hard. They won't give you an STD (unless you let someone else use them). They won't tell you no. And, most important, they won't roll over after coming, hog the covers, or snore! Don't get me wrong, most of the time they can't replace the joys of sex with a "live" partner. But they can certainly make your prostate gland sing a song of glee.

Hannah, the sex toy guru from Toys in Babeland, recommends buying dildos made from silicone. "Silicone is the preferred material for dildos. Silicone dildos are made of a medical grade material that warms up when used. It feels more like the real thing." They come in a great range of sizes and colors. You can also boil silicone – something that you can't do with dildos made of other material. "Three minutes of boiling water is going to kill just about anything."

Non-silicone dildos are made from materials that are more porous. So boiling these toys won't kill all of the germs that live in the little pores. It is best to use non-silicone dildos on only one person.

Toys In Babeland
707 East Pike, Seattle 98122
(206) **328-2914**, www.babeland.com
Hours: Mon.- Sat. 11am to 10pm
Sun. 12noon to 8pm.

Fall 2001

FREE

AMPHETAZINE #25

The
Crystal
and
Violence
issue

The Drugs Made Me Do It

Ask Dr. Dick

Where s Jason?

Personal Stories

Self-Defense

Published four to six times a year, *AmphetaZINE*'s distribution is tightly controlled, main outlets being the needle exchanges, bars, and bathhouses that tweakers are known to use. It is never sent through the mail. Consequently, if you're not a user you never see a copy; this prevents the necessarily explicit content from upsetting more conservatively minded individuals. "We didn't concern ourselves with people who might view the information as offensive," explains Raye, "as we always felt we were part of an important cause. We knew that if outside people saw this for the first time, it might be difficult to understand the editorial and design choices made... Occasionally we got negative feedback from within the graphic design community, but in general, other design professionals have been really supportive." Whatever the criticism or praise from their peers, the ultimate test for Modern Dog is, did the *AmphetaZINE* redesign achieve its aims? "Yes, and well beyond. We heard back directly from users. They started asking volunteers at distribution locations about the upcoming issues months in advance. That never happened before. We even heard that a few users walked into treatment facilities with *AmphetaZINE* in hand. As long as we are in business, we will take nonprofit work for social causes we believe in. It's the work that makes us feel good at the end of the day."

Feedback

Susan Kingston has been with NEON for six years and is now editor and producer of *AmphetaZINE*. "Our team of six peer educators distribute *AmphetaZINE* through their social, sexual, and drug-using networks," explains Kingston. "It's our primary vehicle for disseminating timely and important HIV prevention and health education in a format that really appeals to our target population. It's an important tool for our peer educators who use it as a way to introduce new health topics into their outreach, promote local services, and encourage conversation. Our readers love the blend of humor, sexual imagery, and cultural reference that really is their own, and we have a very committed readership! Modern Dog came along just when we were ready to become 'big time' shall we say. Our readers, by nature, bore easily so it was clearly time to spice things up! They offered their services at prices we could truly afford and I think we actually got WAY more than we paid for. I can write words. I can write the advice, the tips, make it funny, make it erotic, make it stir an emotion, whatever, but the real hook is always the look. If people aren't pulled into the piece, if something doesn't catch their eye, then it doesn't matter what I've written because no one is reading it. Effective graphic design is absolutely critical if we want to help readers really 'get' what we're saying without relying on the words."

11 COVER AND SPREAD, ISSUE 25, THE VIOLENCE ISSUE The most difficult aspect of the design was that although it had to be fun and entertaining to attract readers, it could not make drug use look fun. Modern Dog trod a difficult middle path, aware that they mustn't trigger any former users or encourage anyone who was thinking about starting.

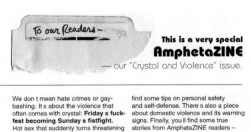

Ellie Ridsdale
Walking the Way to
Health Initiative

5

A year after finishing her Masters degree at London's Royal College of Art, Ellie Ridsdale took part in a project with the Helen Hamlyn Research Centre. Set up to explore the implications of social change and creative, accessible design for all, the center, along with research partner the British Heart Foundation, had a tough job for her; encourage local communities at risk from heart disease to exercise regularly.

Background research

Ridsdale was approached, she says, because of her graduation project in which she examined the difficult task of communicating scientific theories and related health issues to the layperson. For this new project, Ridsdale was asked to research and help communicate the importance of walking to health. It was a project that addressed a core concern of the Helen Hamlyn Research Centre—that older people should be encouraged to lead active, independent lives—and reflected a growing focus on social issues in the School of Communications at the Royal College of Art (RCA).

The project was part of the Walking The Way To Health initiative, run jointly by the British Heart Foundation and the Countryside Agency, and launched in 1998 to encourage local communities at risk from heart disease—such as older people, low income groups, and South Asian families—to exercise regularly. Both external research partners had already undertaken extensive investigation into how and why a regular activity like walking could save thousands of lives a year, but the message needed to be delivered to the targeted communities clearly, positively, and encouragingly.

User research played a key role in the study. Because existing walking groups had already been established through the Walking The Way To Health initiative, Ridsdale was able to work closely with two UK user groups; local walking group Walsall Walk On in the West Midlands, and Keighley Women's Group in West Yorkshire. Two areas were identified as needing design attention: maps for facilitation and posters for motivation.

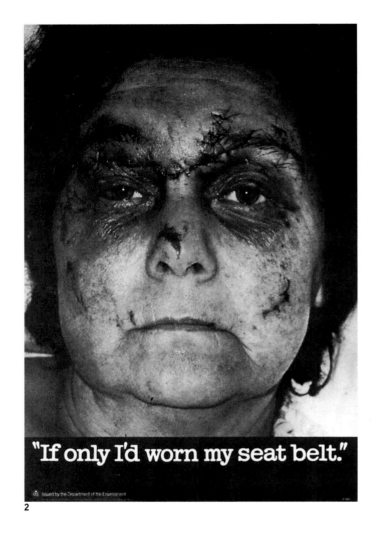

"If only I'd worn my seat belt."

Issued by the Department of the Environment

2

1

1 BACKGROUND RESEARCH Traditional images of sport were examined and rejected as being exclusive imagery that had a negative impact on the target groups—generally sedentary people who would be put off by these images of young, committed athletes.

2 PUBLIC HEALTH CAMPAIGN POSTERS Ridsdale researched many types. She saw their shock tactics as overused and therefore ineffective, "plus, we weren't trying to persuade people to give something up, so I didn't think this fear approach was appropriate."

3 COMMUTER IMAGES Ridsdale conducted a photographic study of commuters, workers, and walkers and "bikers" which enabled her to make visual comparisons between the activities of walking and commuting via public or private transport. "The photographic study of people commuting revealed that the most frustrating and senseless part of the journey was waiting. Similarly, it seemed that people who were using their cars for short journeys would often be stuck in traffic for long periods of time."

3.1

3.2

3.3

4 INITIAL POSTER IMAGES Contrasting the calmness and freedom of walking with the frustration, freneticism, and discomfort of commuting led to Ridsdale using images of grass and walkers' feet on the original posters.

5 AUDIENCE NEEDS This direction for the poster was a failure: the walking groups "didn't get it at all," says Ridsdale. The message had to be a lot more direct and straightforward.

4.1

4.2

1 **Elvet Banks**, Durham	6 **Castle Park**, Bristol	11 **Broadfield**, Rochdale
2 **Castle Hill**, Kendal	7 **Derby Park**, Bootle	12 **Loughton Park**, Milton Keynes
3 **Basingstoke Common**	8 **Craigie Park**, Ayr	13 **East Park**, Southampton
4 **Arboretum**, Nottingham	9 **Arboretum**, Lincoln	14 **Barrowfields**, Newquay
5 **Cae Glas Park**, Oswestry	10 **Central Park**, Dartford	15 **Dale Park**, Margate

There are open green spaces in every British city, just waiting for you to visit. Regular walking helps us all feel better and live longer. So go out more, put walking in your life and feel the difference.

Strategies

At Keighley, where English is a second language for many, walkers were generally daunted by maps. However, at Walsall, where there was an effective series of maps and leaflets, it was felt that although there wasn't a need for maps of led walks, they did encourage people to take independent walks. The Walsall Walk On group had a strong identity: they had worked with local artists and the community to produce a mosaic, signposted walkway in a local park, and had liaised with local doctors, dieticians, and retailers, who contributed toward a voucher rewards scheme for walkers. The group was also interested in a range of posters to prompt people to walk.

Gathering existing health and exercise imagery, Ridsdale saw a fundamental problem. "Images of physical activity in advertising, on television, and in magazines show young, healthy, disciplined, and committed athletes ... to a sedentary person, just the word 'exercise' can be daunting, so images of young, beautiful athletes are going to be offputting. On top of that, research showed that people have a fear of failure and do not want to 'look stupid'." So Ridsdale's first task was to present visual images that communicated inclusively with their core audience.

Looking at existing public health campaigns showed that the shock tactics employed by so many, dating back to the 1960s, were losing their impact. But before tackling this, Ridsdale had to find out whether a poster was an effective means by which to persuade more people to walk. She looked at various studies, including one undertaken in a shopping mall. An area was observed for six weeks with and without posters encouraging people to walk rather than use the escalators. Stair use increased significantly during the four weeks when the poster was in place. It was clear that posters could trigger exercise, but where were the best places to put them? More studies resulted in four optimum "trigger" locations:

1 elevators—to target people at the point when a decision is made to climb the stairs or take the elevator;
2 bus stops—to highlight that many people wait for a bus for longer than it would take them to walk the journey;
3 roadside billboards—to target people who use their cars for short journeys when they could walk instead; and
4 Doctors' waiting rooms—to reach a captive audience of people who may be at high risk from coronary heart disease (CHD).

6 SITE-SPECIFIC POSTERS The first four posters Ridsdale produced were shown to 15 participants in a led walk, a church men's group, and a meeting of walk leaders. They came back with general comments and requests, such as "All posters should include the statement 'everyone needs 30 minutes walking five days a week at a moderate pace,' and 'don't use small print'."

Specific feedback included:

6.1 People were confused as to the setting and felt that there was little you could do in this situation; after all, you have to wait in a waiting room.

6.2/6.4 The groups felt that this poster lacked impact. "The men said the obvious reply to the question is, "The bus," recalls Ridsdale.

6.3 Comments included "Better to say 'step up your way to health'."

6.1

6.2

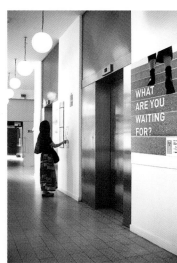

6.3

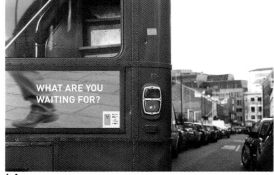

6.4

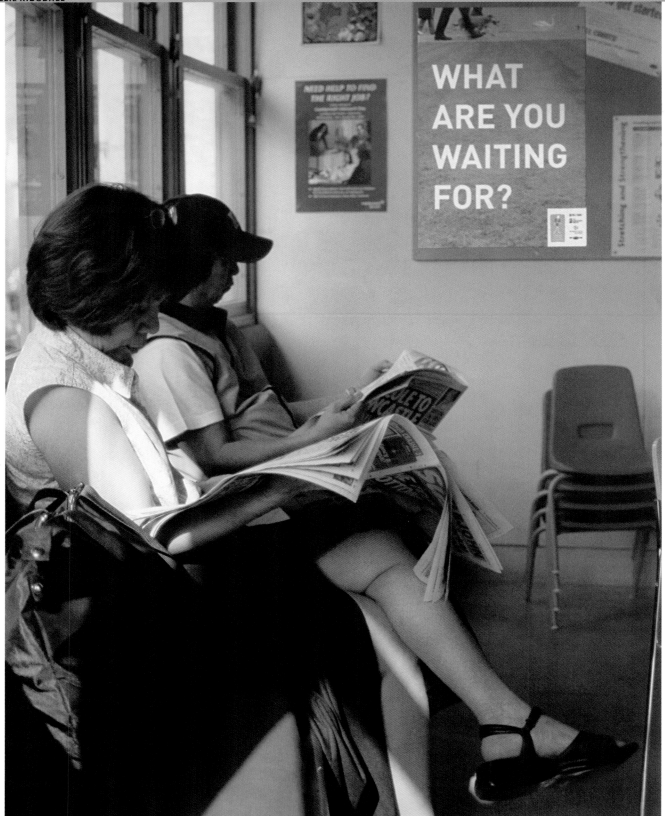

TRY WALKING YOUR WAY TO HEALTH

Regular walking prevents diabetes, halves the chance of a heart attack and reduces the risk of bowel cancer. So get out more, walk your way to health and experience the energy!

7.1

Incorporating responses

Ridsdale began on a series of site-specific posters to be displayed in these four locations, but admits her first solution was that of a "designer designing for designers"; a poster that communicated with its intended audience in a very direct and obvious way was needed. "It's very hard to design for the user because at college so many students design for their peers, and they're very different things. A trendy, design-savvy audience wouldn't need a banner on a poster at all, but the focus groups and users here needed them because, for

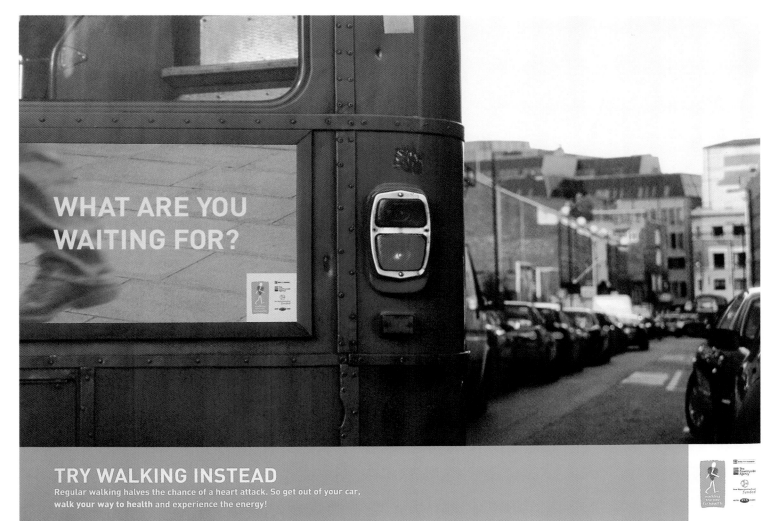

7.2

"It's very hard to design for the user because at college so many students design for their peers, and they're very different things."

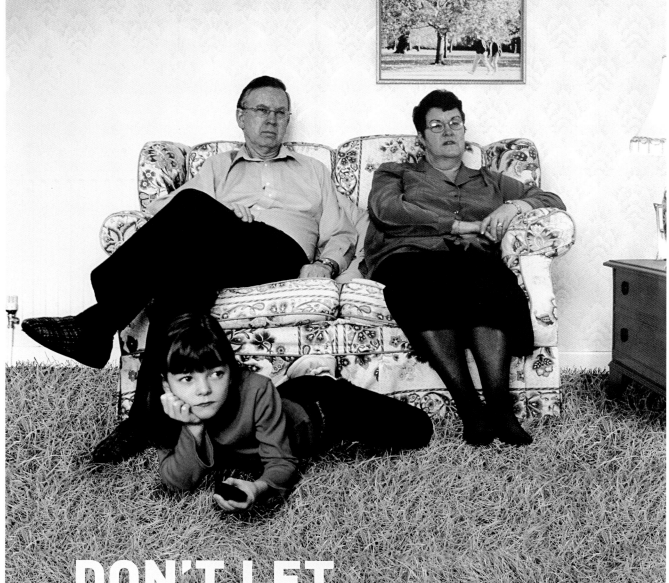

DON'T LET
THE GRASS GROW
UNDER YOUR FEET

The nearest park is closer than you think,
walk your way to health and experience the energy!

8 FURTHER WORK Ridsdale continued to work for the client once the research project had finished, creating this additional poster.

9 ISOTYPES Ridsdale looked at ways of simplifying information, such as Constantine Anderson's isometric map of midtown Manhattan, and Otto Neurath's isotypes (International System of Typographic Picture Education), a collection of maps, diagrams, charts, and symbols which Neurath hoped could be understood by anyone regardless of language or education. The symbols did not represent the way a thing looked, but the "essence" of it.

10 MAPPING RESEARCH Ridsdale began by looking at mapping over the millennia, including an inscribed, baked clay tablet from Iraq, c. 2300BC, which recorded land ownership, and a medieval world map.

9.1

9.2

9.3

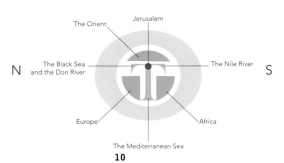

10

them, that was what made a poster a poster, and if they couldn't read it as a poster, something giving them information, then there was a likelihood that they would simply ignore or dismiss the message."

Four posters and a questionnaire were presented to user groups. They felt that three of the posters delivered a clear, relevant, and effective message. The fourth—set in a doctor's surgery—was less successful, so was changed. Ridsdale found working with the focus groups challenging. "You have to judge what's important and what isn't. For example, if a focus group or user simply says they don't like a color, you have to weigh up the impact of that on the design ... but if they say maps don't motivate them to walk you have a clear-cut responsibility to act on that. It's hard but useful, and the more you do it the more you learn about refining what you're getting."

Revisions were made and four posters finally produced, along with two "poster shells"; posters with a blank space in the middle to allow walk leaders to put in their own information about the local group.

Ridsdale turned her attention to the mapping. She looked at ways of "demystifying" the information in local maps. "A good map enables its viewer to read information rather than just see it. If it's over-complex and confusing, it may send out the message that technical knowledge is needed to walk. And it has associations with long hikes and extreme activity." Added to that, map text is often extremely small and difficult to read. Four "no-map" maps were explored which, although never realized, provided useful feedback for the research report. This included recommendations for translating material for walking groups, and creating "a simple, photographic time line which could be photocopied and handed to people wanting to walk independently."

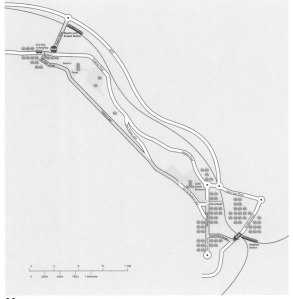

Steeton via Cliffe Castle

- Turn left out of Keighley Station, walk along Bradford Road for a short distance and take the first right into Cavendish Street.
- Walk along North Street and enter the park through the entrance opposite East Avenue on Skipton Road.
- Follow the paths in the park past the Cliffe Castle Museum and the bird garden.
- Exit the park on Spring Gardens Lane.
- At the fork in the road, go left onto Hollins Lane (there are no footpaths).
- Follow the road down a steep hill into Mill Lane, which comes out on Skipton Road at Steeton.
- Return to Keighley by bus, train or walking.

Time: Approx 1¼ hr

Buses to Keighley are 18, 24 and 38 minutes past the hour.

11 PICTOGRAMS Ridsdale's first simplified map was this version of the traditional Ordnance Survey (Britain's national mapping agency) map, using pictograms and editing out unnecessary information.

12 PHOTOGRAPHIC MAP This time-line map married simple directions with the associated locations to offer a "no-map" map that is easy to follow.

13 ALTERNATIVE VIEWPOINT This simplified map takes a ground-level viewpoint in place of the conventional aerial one, and shows the gradient and terrain of the walk.

14 TIME-ZONED MAP The fourth map, a 'time-zoned' map of Keighley, was given to a walking group for comments. The general consensus was that it was more important to show the time it takes to travel to places than the distance, and points of local interest were requested as a means of orientation and to act as a motivator to visit them. Although the map formed a central part of the Helen Hamlyn Research Associates symposium in 2001, it was never produced.

Steeton via Cliffe Castle

hours (mins) 0	30	60	90 hours (mins)

Turn left out of Keighley Station, walk along Bradford Road for a short distance and take the first right into Cavendish Street.

Walk along North Street and enter the park through the entrance opposite East Ave. on Skipton Road.

Follow the paths in the park past the Cliffe Castle Museum and the bird garden.

Exit the park on Spring Gardens Lane.

At the fork in the Road, go left onto Hollins Lane (there are no footpaths).

Follow the road down a steep hill into Mill Lane, which comes out on Skipton Road at Steeton.

Return to Keighley by bus train or walking.

Buses to Keighley are 18, 24 and 38 minutes past the hour.

12

time (minutes) 0 25

Turn left out of Keighley Station. Walk along Bradford Road for a short distance and take the first right into Cavendish Street.

Walk along North Street and enter the park through the entrance opposite East Avenue on Skipton Road.

Follow the paths in the park past the Cliffe Castle Museum and the bird garden.

Exit the park on Spring Gardens Lane.

At the fork in the Road, go left onto Hollins Lane (there are no footpaths).

13

Keighley town centre map showing the maximum amount of time it takes to get to any point within each circle, based on a slow walk of 3 miles per hour.

Feedback

Peter Ashcroft at the Countryside Agency recalls, "we took Ellie on to do the marketing but quickly realized she was very strong on concepts, and very self-sufficient, which was great." He believes Ridsdale had a number of aspects to her personality which enabled her to "fit into the culture of social responsibility well. She wasn't resistant to it, and didn't challenge it, and she was very good at listening to what was needed," he says. These factors meshed with aspects of her design education and experience to give her a vital edge in visual understanding and communication that was totally appropriate to its audience.

Ridsdale's relationship with the Countryside Agency continued beyond the project, and she produced further walking posters, making the project and its continuation an undoubted success. Ridsdale also found the project useful. As she explains, it taught her "a lot about research, including constructing questionnaires, using and distilling feedback."

50 75 time (minutes)

Follow the road down a steep hill into Mill Lane, which comes out on Skipton Road at Steeton.

Return to Keighley by bus train or walking.

Buses to Keighley are 18, 24 and 38 minutes past the hour.

Caro Howell and Dan Porter
i-Map On-line Art Resource

Creating an animated website for art education doesn't seem unusual. However, when the target audience is registered blind, with varying degrees of visual impairment, the project might appear to be pointless or impossible. The reality is that i-Map is a pioneering and award-winning example of inclusivity.

Inclusive education

Caro Howell and Dan Porter's creative energies and positive belief in inclusivity produced i-Map, an on-line art education resource for the visually impaired. Howell specializes in working with young people outside formal education, and people with sensory impairments. Dan Porter was involved in museums and art history before undertaking formal training in web and multimedia design. In 2001, London's Tate Modern was hosting an exhibition which provided an ideal launch pad for i-Map. The plan was to let on-line visitors explore the ideas, innovations, and working methods of two artists featured in the gallery's show—Matisse and Picasso. i-Map complemented the exhibition, but was always intended as a lasting resource.

The project was about capitalizing on the pedagogical breakthroughs Caro had made and preserving the positive learning outcomes of the touch tour experience. Few people were taking the touch tours at the Tate, and this was as much to do with the time-consuming practicalities of organizing a visit as the assumption by blind visitors that modern art isn't for them, an assumption that i-Map successfully challenges.

Developing the site

"The project was shaped through dialogue," says Porter. "Caro and I were committed to working closely together, to utilizing all of her knowledge and experience in the galleries, to trial and error, and to listening to our potential users." Howell continues, "The final working method was for Dan and I to develop a storyboard together that mapped out the structure of the exploration visually, verbally, and in terms of the line drawings. Dan would then create the animation and I would put the words to this, and create the line drawings, based in large part on the animations. We would then fine tune the text together." Porter adds, "The design and animation was my responsibility, but Caro had the power of veto. I occasionally had to bow to her experience and rework the animations when she thought them too complex, but that didn't happen often because everything was so thoroughly storyboarded up front."

The viewing experience

i-Map was constructed in two tiers: one using text and on-screen, interactive Flash animations, and the other text alone. For the text-only version, a downloadable PDF file is available. This contains high-contrast images designed to be printed onto heat-sensitive plastic to form a raised image that can be felt while listening to a screen reader recite the text.

"Of course, sight is an integral part of engaging with visual art," explains Howell, "and lacking sight does have a profound impact on one's relationship to it, but blindness alone doesn't negate or preclude engagement. I wanted the site to be as accessible to as many people as possible both in terms of their visual impairment and their familiarity with the art." The ideas explored by i-Map are those used to explore art with sighted people. "A common reaction of visually impaired people, both in i-Map feedback and on touch tours, is a sense of achievement. Having attained an understanding about an artist or artwork, they can make an informed personal judgment about it, and this is an enjoyable, liberating experience."

1 FLASH ANIMATION SEQUENCE, PICASSO'S BOWL OF FRUIT, VIOLIN, AND BOTTLE "Perhaps one of the more successful animations," explains Porter, "is the part that allows the user to build up a section of a Picasso still life piece-by-piece, as if they were constructing a cubist collage. Most of those elements are colored shapes, entirely abstract in themselves and barely legible as a fruit bowl even when seen in context. I created so-called conventional drawings of the objects in the painting and morphed them into their cubist manifestations. The point was to convey a sense of the process and of the dynamic way in which these elements related to each other."

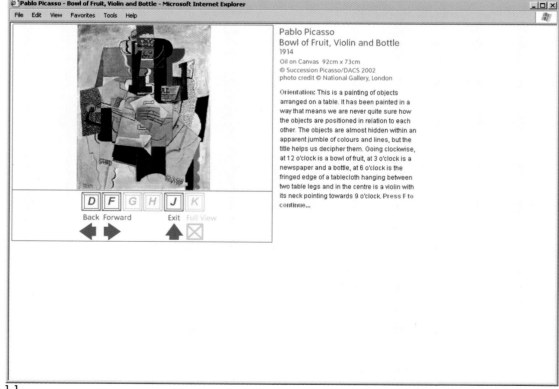

1.1

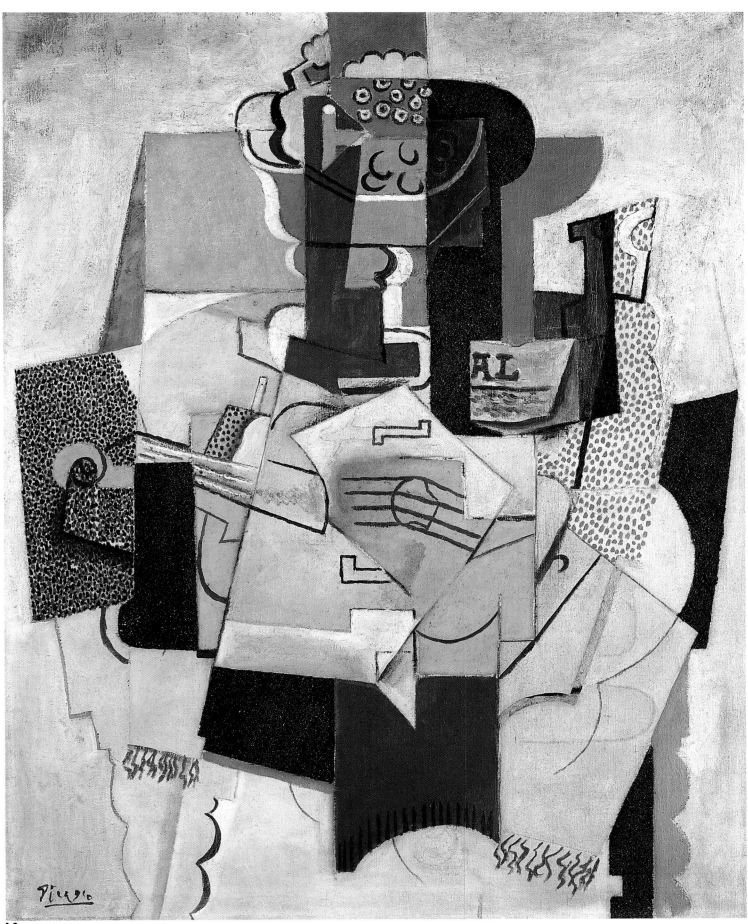

1.3

1.4

1.5

1.6

1.11

1.12

1.13

1.14

1.19

1.20

1.21

1.22

1.27

1.28

1.29

1.30

.7 1.8 1.9 1.10

.15 1.16 1.17 1.18

.23 1.24 1.25 1.26

.31

2 FLASH ANIMATION SEQUENCE, MATISSE'S THE MOROCCANS "Animation replicates the way sighted viewers pick out the dislocated but recognizable bits of an object and mentally reassemble them," explains Howell. "The animation does this in the simplest, clearest, and most seamless way possible. Because neither Picasso nor Matisse ever abandoned figurative subject matter, their art provides a good starting point for exploring some of the foundations of abstraction with visually impaired people. However, it's also important to stress that unlike many approaches to art aimed at visually impaired people, i-Map is not interested in the 'what' so much as the 'why' of art."

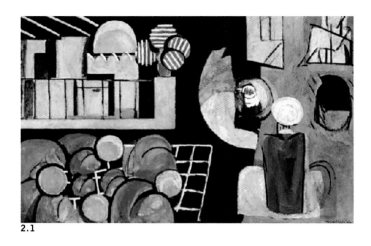
2.1

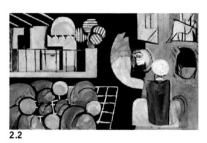
2.2

2.3

2.4

2.5

2.10

2.11

2.12

2.13

2.18

2.19

2.20

2.21

2.26

2.27

2.28

2.29

"Access is about more than lifts, bathrooms, and ramps. It is about giving everybody the opportunity to fully participate in cultural debates."

.6

2.7

2.8

2.9

.14

2.15

2.16

2.17

.22

2.23

2.24

2.25

.30

2.31

2.32

3.1

"i-Map is not interested in the 'what' so much as the 'why' of art."

Writing for sighted and visually impaired readers

"This is less about difference and more about addition," says Howell. There is a need for descriptions of the visual and a greater need for extreme clarity in meaning and structure. "Often visually impaired people have difficulty perceiving the artwork as a whole, their vision is restricted to certain areas, as with tunnel vision. The animation was designed to study the artworks in isolated and magnified chunks to enable the viewer to assemble a clearer picture of the whole image in their minds." For viewers who had little or no useful sight, the text was supported by raised line drawings that performed the same function as the animation but via tactile means.

In his original designs Porter had the text and animations running side by side. "It was a design that tried to be all things to all users. A blind person, reliant solely on text and raised images, would nonetheless have to contend with the distracting presence of the animation. Meanwhile, the user with some sight was expected to follow the text, the animation, and the raised drawings." It had also not occurred to Porter at this stage that a user who required noises to alert them to the presence of buttons would be highly unlikely to be operating a computer with a mouse. Paul Porter is a blind web and computing expert who works for the Royal National Institute of the Blind. "I took a prototype version of i-Map to him," explains Dan Porter, "and asked him to list any obvious design faults. It was really useful just to watch him navigating the site, and his screen reader proved a fantastic tool in disclosing inconvenient or badly prioritized content. Most websites have generic information and links at the top of each page, but it becomes irritating to hear that over and over in an expressionless, synthesized voice." The regular Tate links were shifted to the foot of the page and relevant quotes were added at the top, which was a neat and engaging way of introducing fresh content. Howell sums up, "Access is about more than lifts, bathrooms, and ramps. It is about giving everybody the opportunity to fully participate in cultural debates."

Feedback

i-Map was designed to function independently. Its careful and informed structure, and the nature of the internet, means that it is a worldwide resource for everyone. In terms of inclusivity, it is nothing less than groundbreaking, and it is continuing to evolve. Tate Modern wants to extend i-Map to cover other artists and is actively pursuing the funding needed. "We've had a lot of interest from other institutions who would like to use the i-Map method for their own collections," says Porter, who is already beginning to think of ways to extend its functionality, such as including more audio. i-Map has shown that visually impaired people have an interest in exploring art and has opened up a new area of art education and appreciation. "Thousands of people have downloaded the line drawings," says Howell delightedly, "and the feedback has been extremely positive. Winning the BAFTA [British Academy of Film and Television Arts Award, which i-Map received] has raised the profile of the needs of visually impaired people."

3 RAISED LINE DRAWINGS "Visually impaired people can use the site with screen-enlarger or text-reader software," explains Howell. The line drawings can be downloaded onto swell paper and put through a fuse heater that raises the lines. This equipment is cheap and extensively used by visual-impairment support units in schools, community groups, etc. Alternatively, the RNIB will produce the raised drawings cheaply for individuals and organizations.

3.2

3.3

3.4

Gert Dumbar
Bangladesh Birth-Control Project

7

Gert Dumbar has been at the forefront of avant-garde design for decades and has won numerous awards. Back in 1972, he took on an extraordinary project, one that echoed his colonial childhood in Dutch Indonesia, and helped bring ideas of population control to the illiterate poor of the newly formed nation of Bangladesh.

Health education

Bangladesh was founded in 1971 after a bloody conflict with West Pakistan. When the war broke out, Dr. Zafrullah Chowdhury was training as a surgeon in London. He gave up his study to return home and establish a field hospital to treat wounded soldiers, but it was the surrounding rural poor who became the main patients. The war left Bangladesh with a shattered economy. Poverty was rife and the population was expanding rapidly so there was an urgent need for birth control. Dr. Chowdhury established the Gonoshasthaya Kendra (People's Health Clinic), as a nongovernmental organization. Originally just six tents and an outpatient clinic under a tree, as funds became available it was rebuilt in concrete. Dr. Chowdhury instigated a system whereby medical students went to educate the villagers about health care and, most importantly, family planning.

These barefoot doctors, as they were known, only made passing visits, and the villagers themselves were illiterate. How could they introduce concepts of birth control and leave villagers the means and know-how to use them? The economist Jan Willem van der Eb, a friend of Dr. Chowdhury, was also a childhood friend of Dumbar, and introduced them. In 1972, Dr. Chowdhury wrote to Dumbar, asking if he would help make posters to encourage birth control and emancipation. Dumbar set up a group of young, dynamic graphic designers to start researching the visual perceptions of illiterate populations.

Background research

Dumbar's group began by looking at a study of illiterate people in Ethiopia. The early research uncovered some interesting points. "In the West we are so used to visual imagery that we know what black-and-white photographic images translate into. For example, from a photograph of a young African boy's face dripping with water, we can read that he has brown skin and black hair and he has been in the rain. To the illiterate it seems that this boy has a skin disease." Many illiterate populations were also unable to recognize graphic imagery that most of us take for granted, such as conventions of perspective. The notion of "common sense" also varied. "A woman was shown by a field worker," describes Dumbar, "two equally sized clay lumps. When she was asked which contained more clay, she said they were the same. She was then told to press one into a disc and asked again which one contained more clay; this time she said it was the pressed one, because it was bigger. Another example is from a United Nations [UN] food program. A worker traveled to a remote village to show slides of a grasshopper, a major pest in the area. She asked the villagers to send an urgent message to her if any of them saw this grasshopper so that the UN team could come and destroy it. A swarm of grasshoppers came and ate the harvest. When she returned and complained 'why didn't you warn us?', the villagers said, 'we haven't seen the giant grasshoppers you showed us, only tiny ones!' They didn't understand scale."

1

2

3

4

6.1 6.2

6.3 6.4

5

1 ACTION IMAGE This photograph was interpreted by illiterate viewers as showing a one-legged man.

2 BLACK-AND-WHITE IMAGES This was read as showing skin disease.

3 PERSPECTIVE Illiterate viewers were unable to interpret the depth cues in this perspective drawing.

4 DISTANCE Illiterate interviewees were asked to trace the most direct route between two villages. D, a local plumber, understood the concept of a straight line from laying pipes; the others marked known paths around fields and forests.

5 EARLY SKETCHES A simple sketch showing the contraceptive pill packet and contents.

6 LINE AND SHAPE Experiments with visual legibility.

7 CULTURAL REFERENCE Dumbar did not want to contaminate the visual culture with Western images, so he looked for examples of local design.

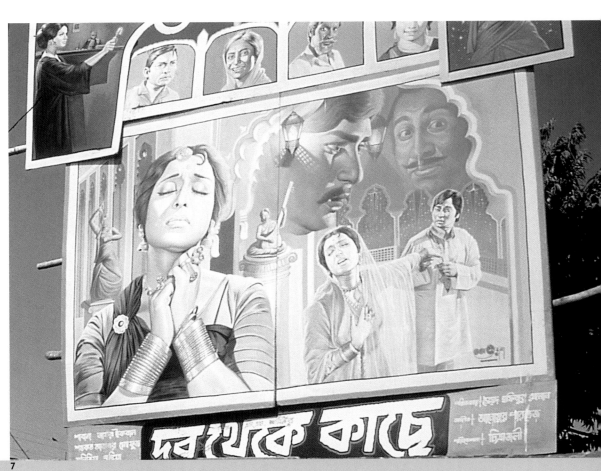

9

Cultural references

"There was no printed material or advertising in the Bangladesh countryside, and only one form of advertising in the cities, which they were very good at—film posters." Dumbar was very concerned about contaminating the culture; he did not want to bring them into the advertising world of multinationals. "There was also a poster used in the cities which showed a mother wearing a mask with a child, with text that read 'if you have a cold wear a mask!' So there was at least the basis for some sort of indigenous visual language."

Dumbar and his group devised a series of posters using photographs of families in front of houses. They were carefully framed to avoid visual ambiguity, and loaded with symbolism that would be readily understood locally. Below a large main image were three representations of the contraceptive methods available: the pill, the coil, and a syringe. Condoms weren't shown because it was women who took responsibility for birth control. Dumbar continues, "The concept was based around a man, a woman, and a house. The type of roof was important; a hay roof means you are poor and a corrugated roof means you are extremely rich. So we showed a man, a woman, and lots of children with a hay roof—they were poor. Then we showed a man, a woman and two children with a corrugated roof—they were rich. For us they look like tourist snaps, but they are loaded with signs and symbols. The barefoot doctors explained to villagers that if you only had two children you could afford a corrugated roof, which gives status. Simplicity!" Dumbar did make one other poster showing a man listening to two women discussing birth control—a radical concept—to help the barefoot doctors in encouraging the women to get men to participate.

8 HAPPY FAMILY Early sketch based on the concept of small families equating to a happy life. This theme was used again later, using photographs rather than drawings.

9 EARLY MORNING At cock crow in the morning, a woman will be reminded to take her pill.

10 BENEFITS OF SMALL FAMILIES The idea behind these contrasting images was to equate large families with hunger; the same amount of food and many children means less food each, whereas less children means more food.

10

Resources

Once the barefoot doctors had talked through the posters, copies were left to be fixed to walls. There were no nails, so glue made from overcooked rice, cheap and readily available, was used. The backs of the posters were printed with dots. "This was very important," Dumbar emphasizes. "In the villages there was no paper. A professional letter writer would come to the village and you would go to them and dictate your letter, but you had to bring your own paper. We were warned to put an image on the back so no one could use the posters as writing paper." Not only letter writers traveled between villages, the villagers themselves did. "Zafrullah asked us to make several versions of the posters. The barefoot doctors gave out different posters to neighboring villagers and homes. Immediately people were looking at each other's posters and discussing them. They were very keen."

Dutch printers printed the posters free and the whole enterprise was financed through donations and sponsorship. "We worked for nothing," concludes Dumbar, "and I managed to find some money to be able to send someone to Bangladesh twice to do the research. It was a jewel of a job to do because it worked, and it was a revolutionary job because it had never been done before. It was very successful and Zafrullah wrote thanking us a few months after delivering the posters. What's interesting for me is that the posters could still be used today, because there were no graphic thrills or frills they have stylistic durability even after 30 years."

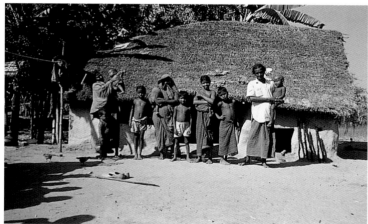

11.1

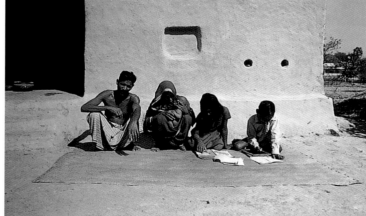

11.2

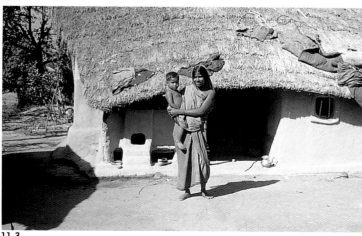

11.3

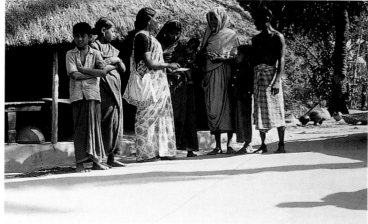

12

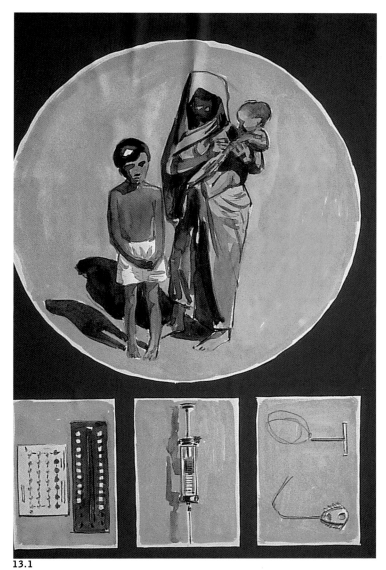

13.1

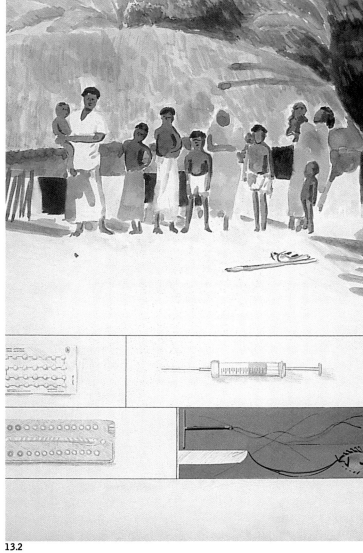

13.2

11 FAMILY PHOTOS Photographs of families taken to illustrate the benefits of small families; better houses, happiness, and being able to afford education for your children.

12 RADICAL IMAGE Showing a female barefoot doctor discussing birth control with women while a man looks on was an attempt to encourage male involvement in contraception.

13 MOCK-UPS Family photographs were linked to images of contraception.

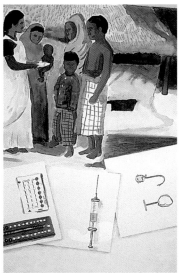

13.3

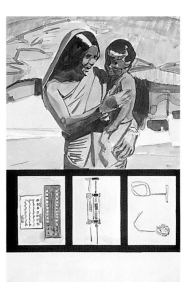

13.4

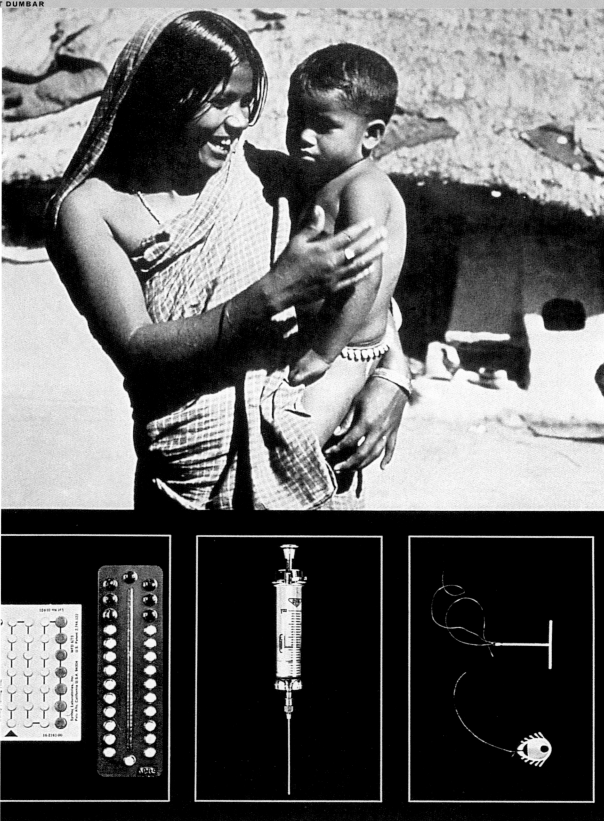

14.1

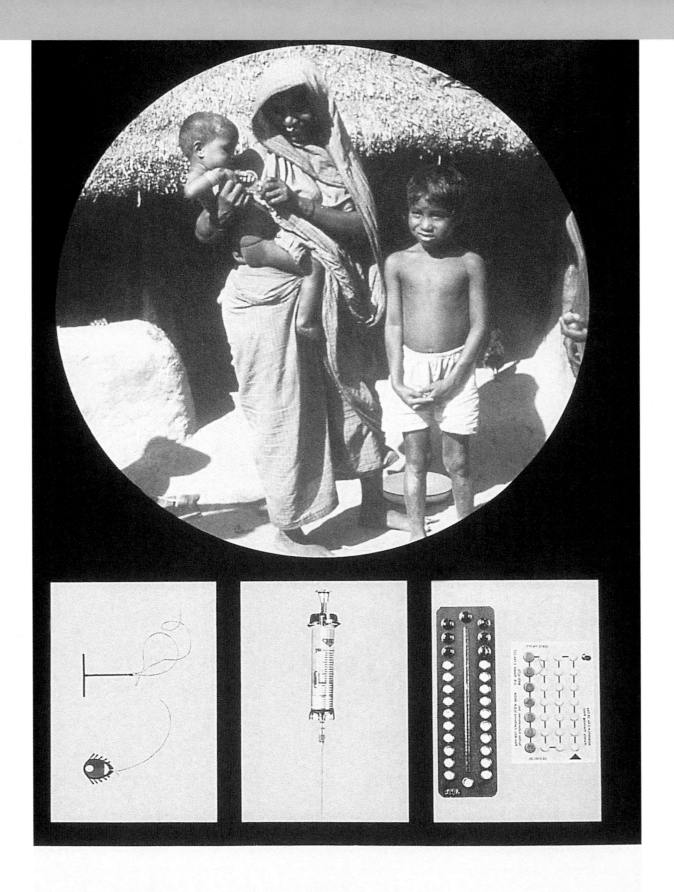

14.2

Feedback

Although an exact analysis of the impact of Dumbar's project isn't possible, it was part of Dr. Chowdhury's early work, and that has been followed closely by bodies such as the UN and the International Planned Parenthood Federation. It has been recognized as an astonishing success. In 1999 the UN Population Fund's representative was quoted as saying, "Bangladesh has made some remarkable achievements in population programs; the knowledge of family planning is almost universal." The same report also described the birth rate in Bangladesh as having been halved in the past 25 years, with the annual growth rate down to 1.7 percent. There can't be any doubt that Dumbar's efforts and insight have contributed to this incredible accomplishment. However, Bangladesh still remains three times more densely populated than India. The UN predicts that the population could double by the middle of the twenty-first century. The number of poor will inevitably increase and the pressure on resources is likely to cause a further deterioration in the environment and in living conditions for most Bangladeshis.

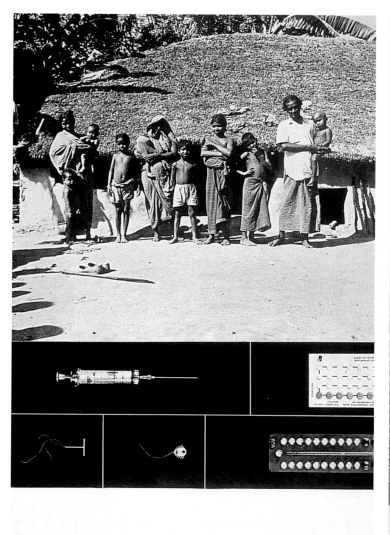

14.3

14.4

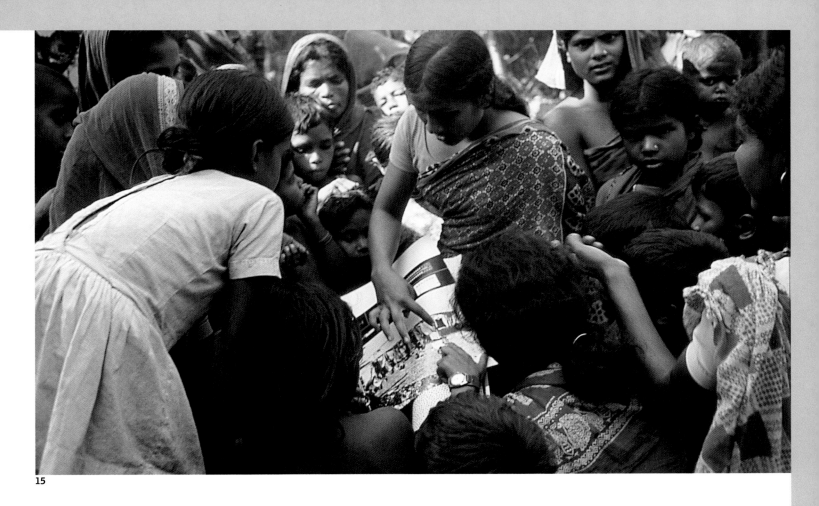

15

14 FINAL POSTERS (and previous spread) The barefoot doctors talked the villagers through the posters, outlining their narratives. Wealth was demonstrated by being able to afford education and corrugated roofs.
A series of different posters was produced and handed out to neighbors and nearby villages to encourage people to discuss the posters between themselves. The posters were 8 x 16in (40 x 20cm), portrait format, black-and-white. These posters were carried into the countryside on foot, so size and weight had to be taken into account.

15 DISCUSSION Barefoot doctor talking villagers through the posters.

16 PRINTING ON POSTER BACKS Dumbar printed a pattern of dots on the rear of the posters to prevent villagers from using them as paper—a simple, but vitally important idea. Without this, villagers would have used the rear of the posters for blank paper and the entire project would have been undermined.

16

"It was a jewel of a job to do because it worked, and it was a revolutionary job because it had never been done before."

Worldstudio Foundation
Sphere Magazine

8

Ethical editorial is, for the most part, risible in design terms. There are mitigating factors such as cost–of both good designers and good imagery–and the use of appropriate stocks, inks, and suppliers, but those alone can't account for the sheer ugliness and unruliness of the design in many ethically driven magazines. One exception to this rule is *Sphere*, a publication serving the American design community.

Inspirational design

New York–based *Sphere* was conceived in 1994 by designers Mark Randall and David Sterling as the magazine of Worldstudio Foundation. This nonprofit organization is funded in part by Randall and Sterling's for-profit design studio, Worldstudio Inc., and in part by events such as an annual gala in which one everyday object, such as a chair, clock, or lamp, is redesigned by celebrity creatives, then auctioned. "From Worldstudio's conception, we wanted to work on projects that reached beyond the bottom-line needs of our clients and for which we had a true sense of ownership. In order to establish ourselves within the creative community—and to define what our organization was about—the first thing we did was develop *Sphere*.

1 CREATE! DON'T HATE LOGO
Logo for the Worldstudio Foundation Campaign for Tolerance, designed by Worldstudio Inc.

2 SPREAD AND COVER FROM *SPHERE*
"*Sphere* has always positioned itself at a point where design meets pressing social, political, environmental, and educational issues," says Peter Hall, *Sphere* coeditor. Past issues of the publication have been devoted to themes such as gun control and domestic violence, and boundaries and racism. (Cover illustration, Josh Gosfield.)

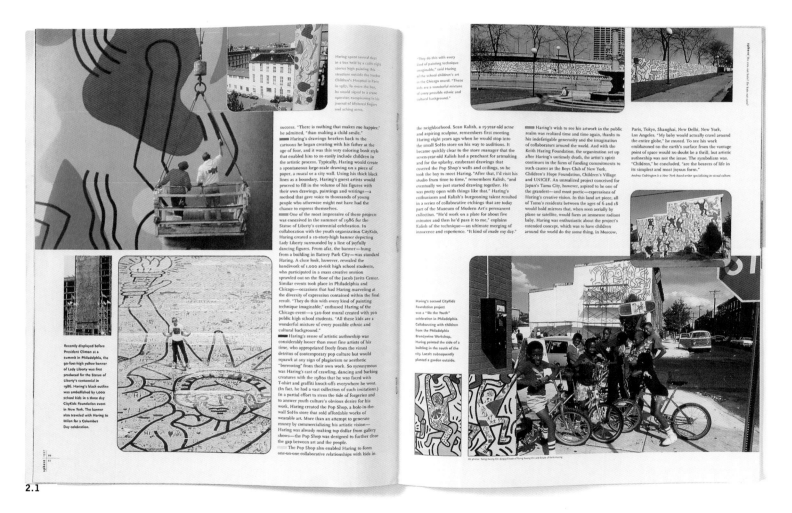

2.1

"The fashionable approach is to promote graphic resistance, à la Joe Chemo. We do some of that sort of stuff, but we try to be positive rather than preachy."

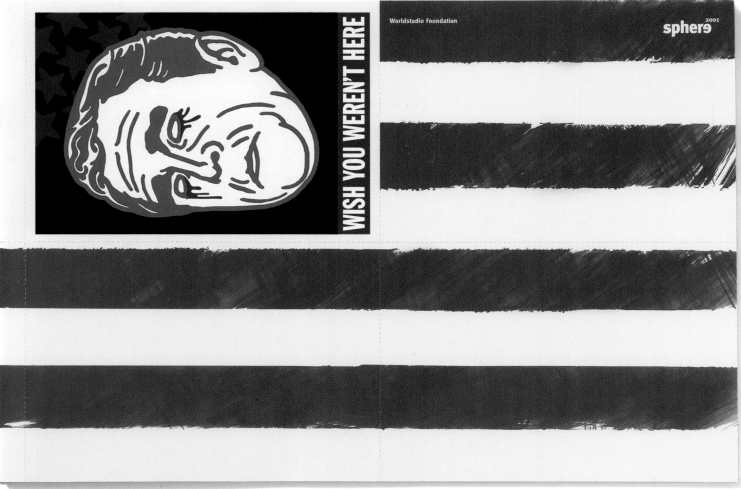

Worldstudio Foundation

sphere 2001

3.1

3.2

3.3

Our goal in creating it was to highlight the social and environmental work of artists, architects, and designers that we admired. To inspire other creative professionals by example," explains Randall. It does this by reporting on specific examples of design and art having improved or drawn attention to local issues (like gun control or refugee housing), and raising concerns around global design issues, and it does so intelligently and aesthetically. Guest designers and artists who've contributed work include Jenny Holzer, Alfredo Jaar, Rhonda Rubinstein, David Byrne, Plazm, Milton Glaser, and Paul Elliman—all invited to contribute, all doing so for nothing. "The fashionable approach is to promote graphic resistance, à la Joe Chemo. We do some of that stuff, but we try to be positive rather than preachy, or anti everything corporate," explains *Sphere* coeditor Peter Hall. "Stories over the years have covered everything from protest graphics to innovative rural housing in Alabama, and postage stamps on domestic abuse to renegade TV stations in Mexico."

The magazine is distributed free to creative professionals on mailing lists such as that of AIGA, the Type Directors Club, and the Art Directors Club, with a print run that ranges from 15,000 to 25,000 copies. Each annual magazine takes a particular theme as its central core, and can only happen if enough sponsorship and funding is in place. The 2003 issue, with its topical theme, Create! Not Hate:

The Worldstudio Foundation Campaign for Tolerance, almost didn't happen. That it did was down to a chance meeting between Adobe Systems' creative infrastructure manager and Peter Hall, from which came a partnership with Adobe that facilitated the resulting exhibition, publication, and mentoring project.

Worldstudio programs

The mentoring program is just one of several Worldstudio programs dedicated to helping the next generation of artists, architects, and designers realize their ambitions and professional hopes while being proactively involved in their communities. Randall describes these programs as "increasing diversity in the creative community and building a more socially responsive creative studio of the future."

The mechanics of mentorship and scholarship programs vary; sometimes the students will be at-risk high school children, sometimes art-oriented after-school program students, sometimes older students already studying design in further education. "Although we do give to a range of individuals we primarily target minority students, and our criteria also include students who clearly demonstrate their commitment to using creativity to give back to society in some way," explains Randall. Students are paired with creative professionals to work on diverse projects.

3 WISH YOU WERE HERE ISSUE
When, in January 2001, reports surfaced that George W. Bush had only made one official foreign visit in his political career, Peter Hall suggested to the *Sphere* editorial team that they turn that year's issue into a collection of postcards, designed by artists and designers from around the world. Their subjects were issues they thought were worthy of the President's attention, and the tag line was the old postcard cliché, Wish You Were Here. Participants included Milton Glaser, *Adbusters* Art Director Chris Dixon, and musician David Byrne.

The issue, with its controversial flag cover designed by Worldstudio, featuring a postcard by Seattle artist Shawn Wolfe, came out in August and was distributed nationally around the time of September 11, eliciting a barrage of hate mail and virulent charges of anti-Americanism. What Hall saw as the most disturbing characteristic of the flak—its reflection of a lack of tolerance for dissent—influenced the next issue of the magazine. (3.2, Paul Rustand; 3.3, Chris Dixon.)

4 1/4 SPHERE This quarterly newsletter acts as an impetus to the inspirational work seen in *Sphere*. It provides factual information on how individuals can become involved in the issues that concern them most. "We developed the idea of producing it as a series of postcards, each of which would introduce the reader to a particular subject in a condensed form. If they wanted to learn more, there was a link to the full story on our website. It makes the newsletter more interactive and gives it a pass-along quality, as well as making it colorful and cost-effective," says Randall.

5 DISPEL THE PREJUDICE NEWSPAPER PROJECT (following page) As part of the Campaign for Tolerance, Worldstudio also created, with gay and lesbian high-school students, an art journal about homophobia. It was distributed free at the Lesbian, Gay, Bisexual, and Transgender Center in New York, and to gay/straight alliance youth groups across the country. The Southern Poverty Law Center also distributed the newspaper through its Teaching Tolerance initiative. (Artwork, Rafael Esquer, designer at @radical.media in New York, and Anthony X, aged 17.)

www.worldstudio.org/4sphere

¼ sphere

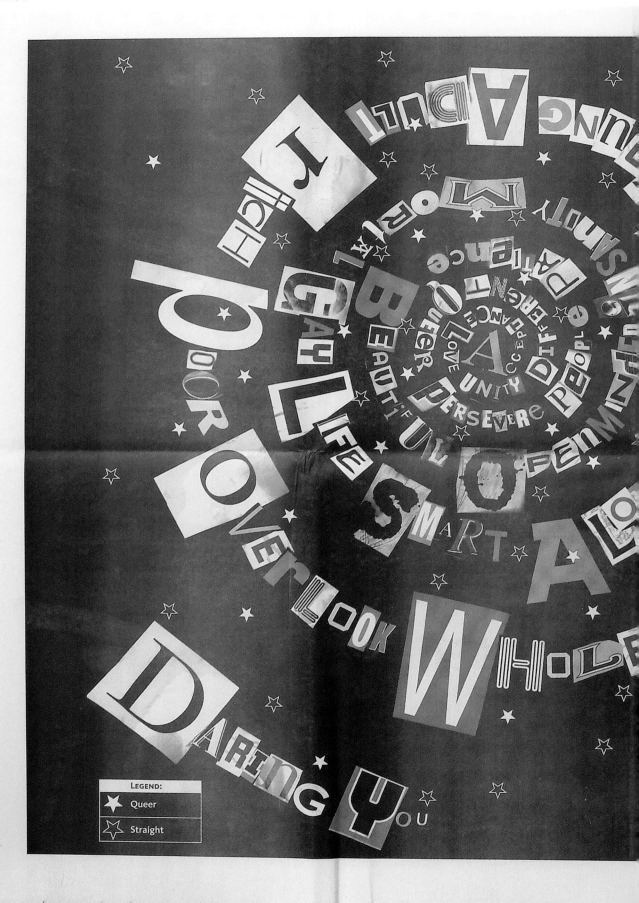

[Worldstudio Foundation Campaign for Tolerance]

LEGEND:
★ Queer
☆ Straight

MENTOR **RAFAEL ESQUER** *@radicalmedia*
MENTEE **ANTHONY** *Lesbian, Gay, Bisexual & Transgender Community Center*

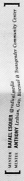

LEGEND:	
★	Straight
☆	Queer

sphere

Worldstudio Foundation 2003

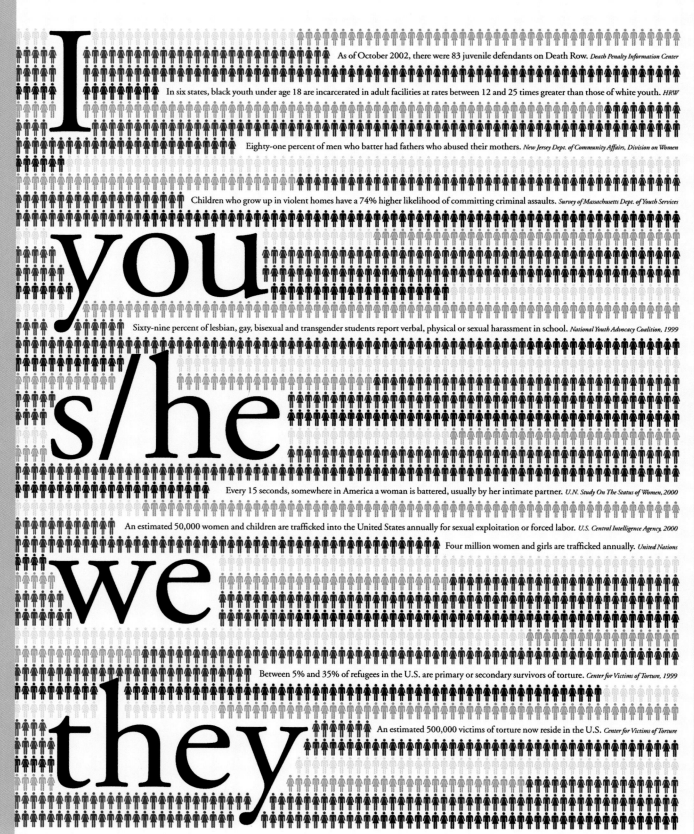

As of October 2002, there were 83 juvenile defendants on Death Row. *Death Penalty Information Center*

In six states, black youth under age 18 are incarcerated in adult facilities at rates between 12 and 25 times greater than those of white youth. *HRW*

Eighty-one percent of men who batter had fathers who abused their mothers. *New Jersey Dept. of Community Affairs, Division on Women*

Children who grow up in violent homes have a 74% higher likelihood of committing criminal assaults. *Survey of Massachusetts Dept. of Youth Services*

Sixty-nine percent of lesbian, gay, bisexual and transgender students report verbal, physical or sexual harassment in school. *National Youth Advocacy Coalition, 1999*

Every 15 seconds, somewhere in America a woman is battered, usually by her intimate partner. *U.N. Study On The Status of Women, 2000*

An estimated 50,000 women and children are trafficked into the United States annually for sexual exploitation or forced labor. *U.S. Central Intelligence Agency, 2000*

Four million women and girls are trafficked annually. *United Nations*

Between 5% and 35% of refugees in the U.S. are primary or secondary survivors of torture. *Center for Victims of Torture, 1999*

An estimated 500,000 victims of torture now reside in the U.S. *Center for Victims of Torture*

I you s/he we they

6.2

6.3

6 *SPHERE* COVER AND TEXT PAGES
The Spring 2003 issues of *Sphere*,
designed by Daniela Koenn, with
editorial and creative direction by
Mark Randall and David Sterling, and
cover design by Santiago Piedrafita.

The project set-up

In 2003, the Foundation decided to make the mentorship scheme the centerpiece of *Sphere*, so they chose to brief 11 collaborative pairs to create a poster each. The final pieces appeared full-size in the magazine. "Each year Worldstudio gives scholarships in art, architecture, and design, and Adobe gives annual awards to students studying graphic design and illustration," explains Randall. As Adobe was a partner in the program, Randall and Worldstudio chose to draw the participants from recent Worldstudio Foundation scholarship winners and Adobe Achievement Award winners. "All of them were college/university level students studying graphic design or illustration as their major; talented students who we felt would benefit from a mentorship with a professional designer." Their task was to design posters on tolerance that were output using Adobe's InDesign 2.0 page make-up program. The final artwork on disk had to be in InDesign, but the document could contain Photoshop, Illustrator files, etc.

The brief was drawn up by Randall and the project set up as a designer–client relationship, with the student–designer team as the "designer" and the Worldstudio/Adobe team as the "client." "This was mainly to give the students a sense of what it was like to work in the real commercial world. Often projects like this can be interpreted as opportunities for artistic self-expression. These posters are meant for the general public. We wanted messages that were clear and concept driven. The comments we gave back to the the teams were usually meant to help them clarify their message; we did not want to

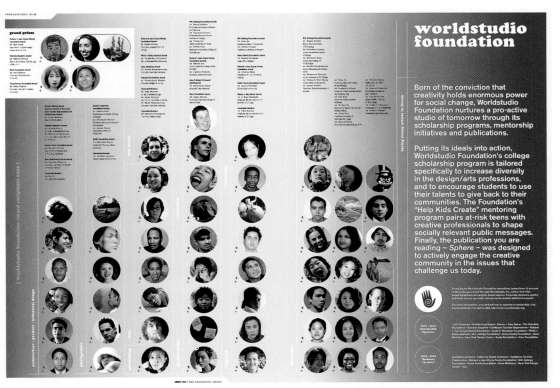

6.4

Stringer/Grant

Jim Stringer, an Art Institute of Atlanta student who was partnered with Bill Grant of Grant Design Collaborative, initially found the subject so large "it made it difficult to get a singular focus on the aspects of tolerance." A strong direction though, was the idea of a community (in this case, the Hispanic community) having an economic value.

7 SKETCHES Regular feedback, being given by both Worldstudio and Adobe, enabled the duo to narrow down the direction in terms of expectations, communication, and target audience. "The feedback was consistent and made for a very real world design experience," remembers Stringer.

8 FINAL POSTER The final poster is a simple exhortation to its viewers to think. "It compels the audience to consider the duality of tolerance and the notion of 'target markets' through these contrasting statements," say Stringer and Grant.

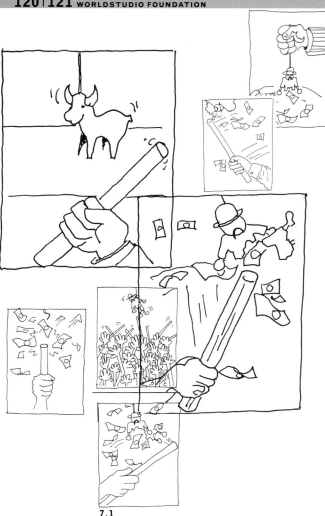

7.1

7.2

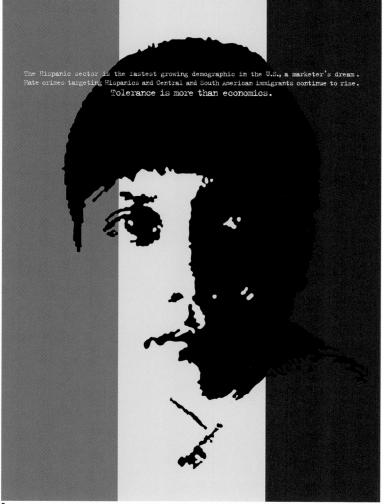

The Hispanic sector is the fastest growing demographic in the U.S., a marketer's dream. Hate crimes targeting Hispanics and Central and South American immigrants continue to rise. Tolerance is more than economics.

8

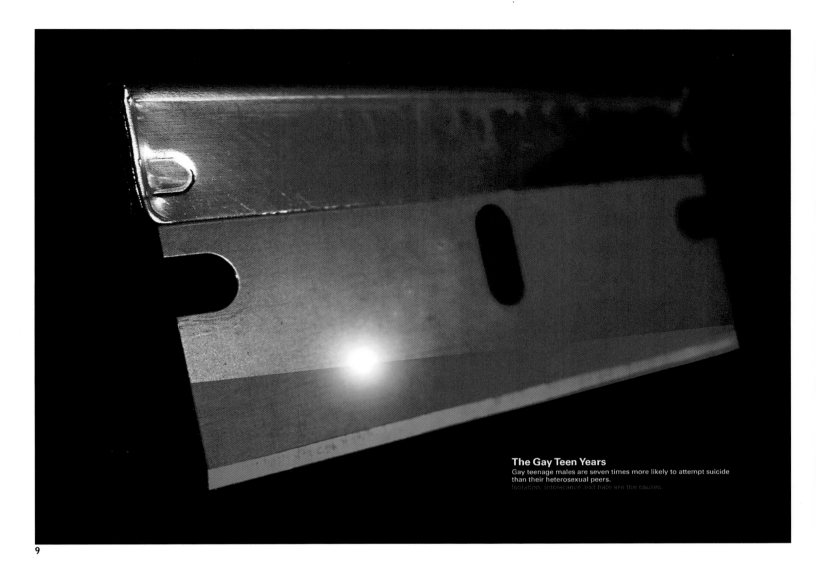

The Gay Teen Years
Gay teenage males are seven times more likely to attempt suicide than their heterosexual peers.
Isolation, intolerance and hate are the causes.

9

Adams Morioka/Taylor
Adams Morioka work with clients such as ABC, Oxygen, Nickelodeon, and Sundance. For the *Sphere* tolerance poster, Sean Adams and Noreen Morioka worked with student Ashton Taylor. "His perceptions of issues important to his age group were invaluable. For us, the experience reinforced why we do this for a living. We're graphic designers who were trained to question, subvert, and make responsible work. It's easy to forget that when the client on a corporate identity is worried about the 'red' in the color palette," says Adams.

9 FINAL POSTER This poster explored the theme of the isolation felt by gay teenagers, who often have no support network of any kind and are seven times more likely to attempt suicide than their straight counterparts. The team wanted to give a clear message that hate, ostracization, and fear are the root cause of this despair, not being gay, a popular misconception.

be too much the art directors. We have had a lot of experience setting up these types of mentoring projects and that, combined with the fact that we are also graphic designers, yielded the results that you see," explains Randall. He is totally positive about the experience. "It was great. The main business of graphic design exists to serve commerce—which I have absolutely no problem with—but it is great to develop a project that has a message you can truly believe in," he says. And he's equally enthusiastic about the visual outcome. "I really feel like the posters achieve what we had hoped for them; thoughtful, strong visual statements with a diversity of messages on the theme of tolerance."

11.3

11.4

10

11.5

11.6 CROSS STITCHING / HOME SWEET HOME

11.1 LONE "THREAD"

Hate Speech CANCER in the heart of America

ALTERNATIVE NO BLACK BLIGHT. BUT RED OLD GLORY IS MADE OF HATESPEECH

11.2

→ Home Sweet
→ America
→ US (lower "us")

words: red
background: white

words + text
(explaining paragraph.)

feet.
feet blue

11.7

Fong/Tran
Karin Fong of Imaginary Forces in Los Angeles, and Jenny Tran, art student, chose to reflect on what they term "everyday instances of intolerance that pervade our life in our own communities."

10 WEB PRINTOUTS Fong and Tran collected statements and snippets of dialogues from websites that revealed prejudices about such things as race, religion, gender, and sexuality. "By collecting these horrible instances of hate speech, we had a body of hateful text to use directly on the poster."

11 SKETCHES AND OIL-ON-CANVAS FLAGS Taking the theme "intolerance exists in the fabric of America," Fong and Tran began to explore imagery around the US flag. They felt that "home turf" would resonate with American schoolchildren, who were the target audience for the poster.

12 FINAL POSTER Karin Fong and Jenny Tran's final poster is a literal interpretation of the hate they found in public forums. A hate speech tears a hole in the US flag and eats away at it.

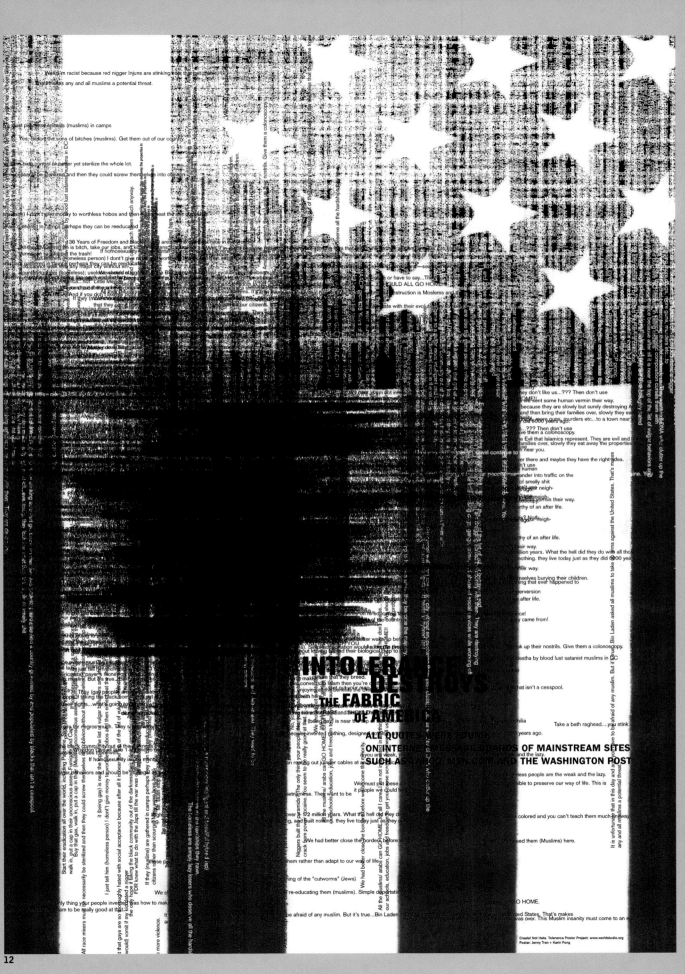

INTOLERANCE DESTROYS THE FABRIC OF AMERICA

ALL QUOTES WERE FOUND ON INTERNET MESSAGE BOARDS OF MAINSTREAM SITES SUCH AS YAHOO, MSN.COM, AND THE WASHINGTON POST

13

14

15

Bierut/Rocha

Pentagram's Michael Bierut and illustration student Patrick Rocha cut to the heart of intolerance and ostracization with their poster, which illustrates the pressure applied on us to look a certain way if we want to fit in. "The concept is a call for tolerance for everyone, no matter how he or she looks," say the duo.

13 FINAL POSTER "Graphic designers like to do this kind of work, but in many ways it is more challenging than a straightforward commercial project. It was interesting for me to engage with Patrick, who brought another point of view to the message," says Bierut. "He was full of visual ideas that were both explicit and ambiguous. Like many artists, he seems more comfortable in the visual world than the verbal one. It was an interesting process to reconcile his image-making with unambiguous messages."

Carson/Katahira

Tsia Carson of New York design group Flat and student Kiki Katahira chose to focus on the division between North and South Korea.

14 FINAL POSTER The poster reflects the fact that during the Korean War, some 10 million Koreans were separated from their families, many of whom are still separated today, unable to communicate with each other in any way.

15 SKETCHES In the development for their final poster, Carson and Katahira looked particularly at the impact of the divide at the personal level.

Randall/Dae Sim

Worldstudio designer Mark Randall and student Dae Hyuk Sim knew they wanted to target a very young audience. "It's where the seeds of hate are sown," they say simply. The pair began by looking at simple, accessible ways to communicate the fact that unity is a great way to fight hate.

16 FINAL POSTER "The team of kids working together with the oversize eraser seemed to capture perfectly our hopes for the next generation," the pair say.

we all have to work together to ERASE hate.

Weapons of Mass Destruction

WMD-28K

28,000 Americans are killed or injured each year as a result of road rage

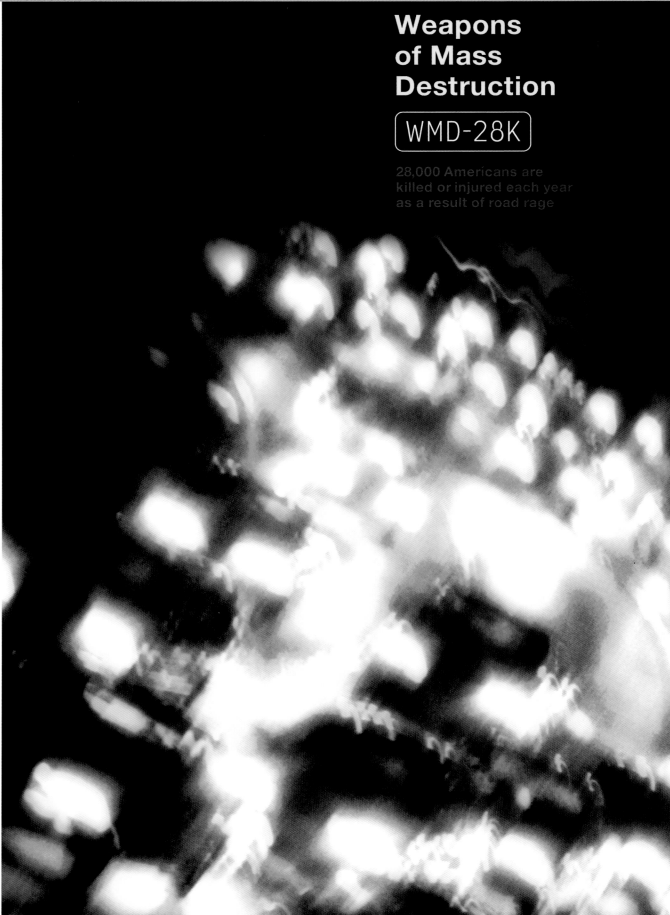

TOLer

18.1

18.2

tolerance

tolerance

18.3

Feedback

Feedback

Working with a sponsor needn't lead to conflict; get the "fit" of sponsor to project right, then follow Peter Hall's advice.

1 Make sure everything is up to par: Key to any sponsorship deal is keeping the sponsor happy without compromising the integrity and creative direction of your project. Hall's policy is to "wow" sponsors with quality to avoid discussions about whether their product or company is getting enough plugs, or whether some story reflects badly on them. "Respect your sponsors, don't try to suck up to them."

2 Turn your sponsor into a partner: Get your sponsor invested in the project, not just financially, but also emotionally.

3 Define parameters: As part of the client team, Adobe's interim responses were a crucial part of the poster project, "but that's not to say Ashwini and Tricia were not open to discussion," recalls Hall. "And with the editorial stories, they were anxious to let us get on and do our thing."

Wickens/Chavalit

Brett Wickens of MetaDesign and student Wonravee Chavalit quickly determined the theme of their poster, which would look at America's very own WMDs, or weapons of mass destruction—automobiles.

17 FINAL POSTER The experimentation with fluid, expressionistic, abstract imagery and language reflect Wickens' background in typography.

Sahre/Atrissi

New York designer Paul Sahre and student Tarek Atrissi decided to come up with a new universal sign for tolerance "suggesting a way to change a negative to a positive."

18 DEVELOPMENT AND SKETCHES The pair looked at ways of appropriating typically negative phrases and images to give a positive message.

19 FINAL POSTER "We see this new hand gesture as a cousin to such positive hand signs as the peace symbol, the thumbs-up, and the I love you sign, even though it more closely resembles a well-known negative hand gesture. And who knows, maybe it'll catch on."

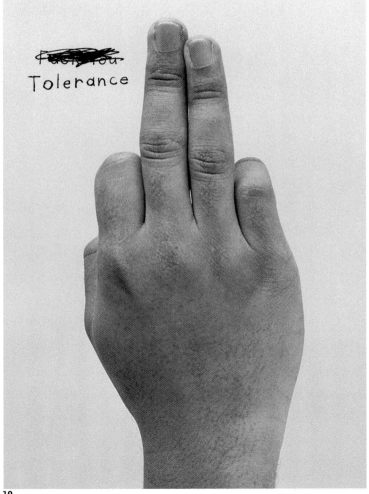

Tolerance

19

18.4

tolerance

18.5

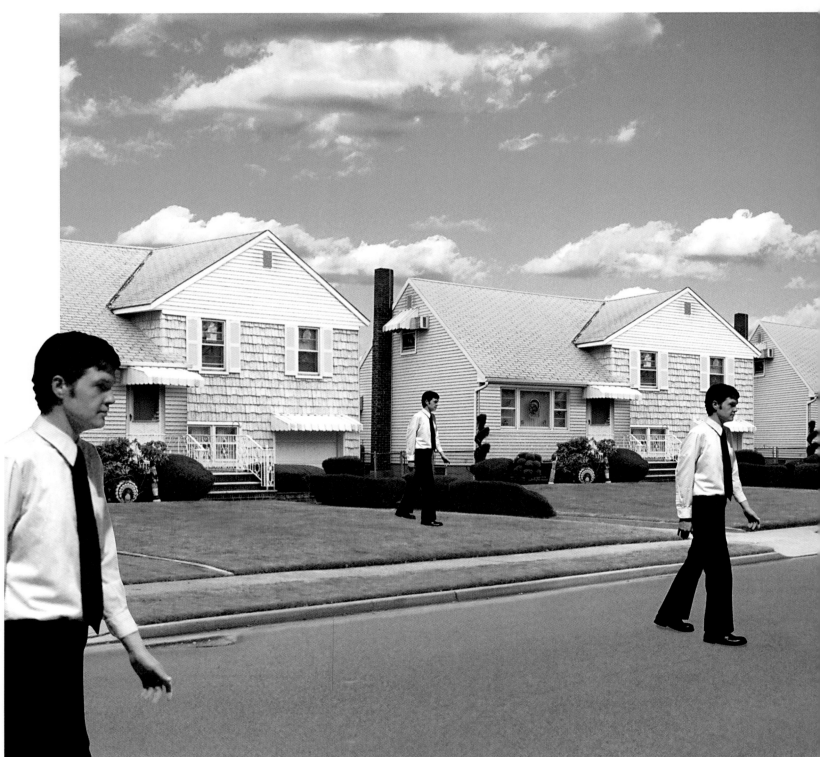

SUPPORT VARIETY

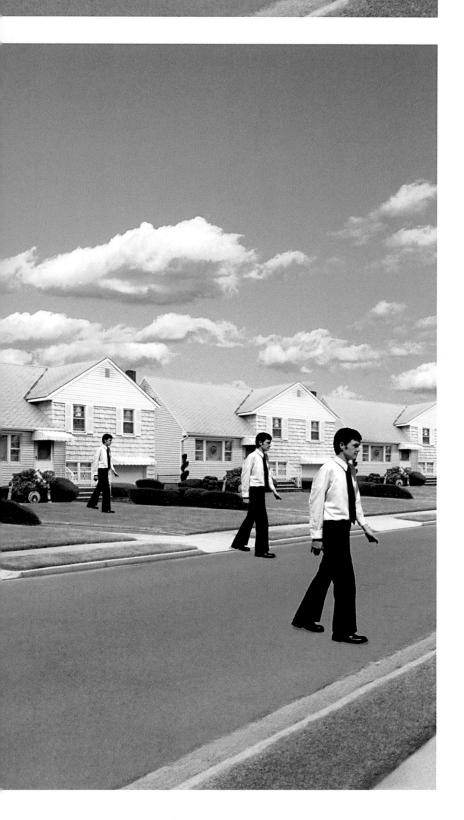

Garland/Azevedo
Arch Garland of design group Flyleaf and student Paula Azevedo went into a parallel world with their poster, where clones don't experience intolerance precisely because they're clones.

20 FINAL POSTER "The message is a warning: when you exchange diversity for security, you're buying into a myth no less surreal than the imaginary neighborhood presented here."

4 Get someone organized on the team: "Our team leader on this project, Mark Randall, is an incredible organizer; patient, and unflappable. This was important because Adobe is a huge organization with a large legal department; there was a lot of paperwork," says Hall.

5 Make sure that you are working with the good guys: Ashwini Jamboktar and Tricia Gellman, the team members from Adobe, did all they could to facilitate and encourage the poster teams without becoming too involved, and with a clear objective. "We wanted to raise awareness of tolerance, spread the word about Worldstudio Foundation and its programs, and disseminate inspiring stories on the power of creativity to effect change. Of course, we hoped that people would use InDesign and other Adobe tools when creating their work, but this project is mostly about enabling a philanthropic project to take place."

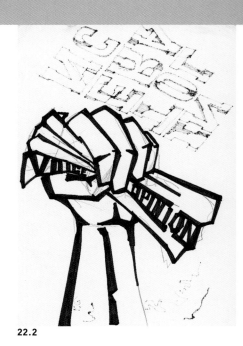

22.2

22.1

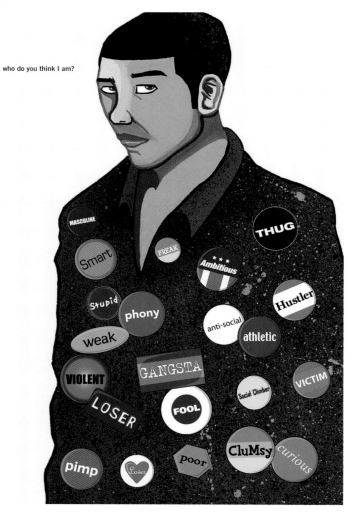

who do you think I am?

21

de Michiell/Baptiste
New York illustrator Robert de Michiell and student Michel Baptiste worked with the idea that intolerance is the result of preconceived ideas about individuals based only on appearance.

21 FINAL POSTER The team's solution takes a confrontational stance, creating a powerful dynamic between viewer and subject, who is hard to categorize due to the conflicting messages he sports.

Rubenstein/Lal
San Francisco designer Rhonda Rubenstein and student Rikesh Lal took the theme of words as race-hate weapons. "It seemed timely to examine freedom of speech, which is a constitutional right, but name-calling and stereotyping encourage hatred."

22 RESEARCH For their typography and content, the duo took to the streets of San Francisco, where they found the graffiti depicted here.

23 FINAL POSTER It was public areas of speech—murals, restroom graffiti, flyers, etc.—that inspired the raw typography and aggressive imagery of this poster.

22.3

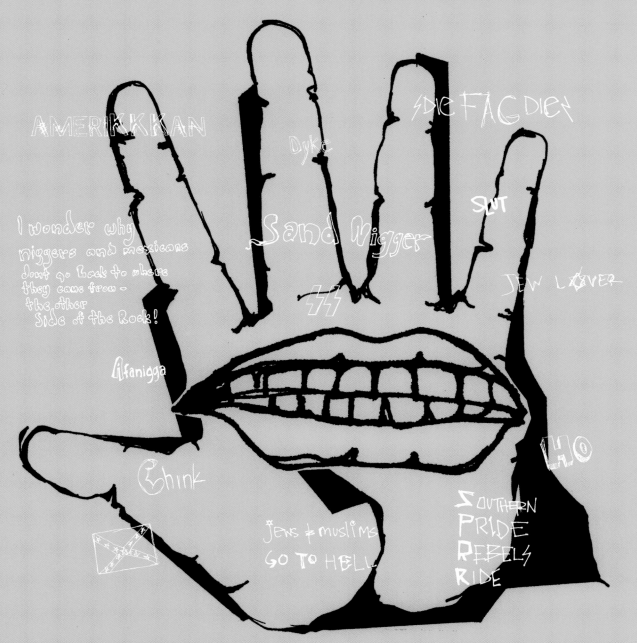

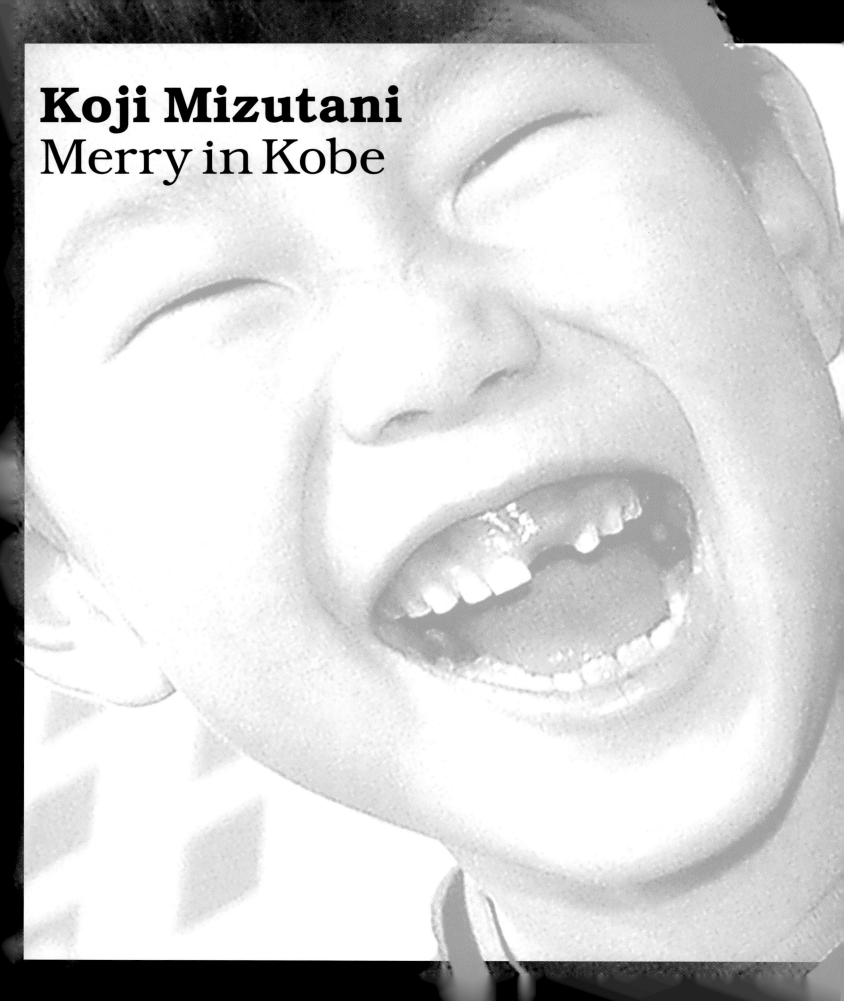

Koji Mizutani
Merry in Kobe

9

Post 9/11, many American designers discovered that they were mute or paralyzed in the face of such horror. While artists began expressing their feelings through work, designers found they could do very little. Such a feeling suggests that good design rarely responds well in a crisis, but Koji Mizutani's work for the devastated city of Kobe has touched people in a spiritual and genuinely uplifting way.

Commercial versus public work

When the Great Hanshin Earthquake devastated the city of Kobe in 1995, Koji Mizutani took a swift, more proactive approach in his response than any in New York's design community felt able to. "Walking and looking around the destroyed area, the reality far exceeded what we were hearing and seeing on the news. It left us speechless and frustrated with the sense that we were powerless to make an immediate contribution. Slowly we realized that our part was to be played in the long-term recovery of the people, both mentally and spiritually."

The event acted as a timely catalyst for the highly respected art director, designer, and ad man. He had run a lucrative business for 25 years, had a great client list, and a string of awards to his name, but in 1995 Mizutani decided to turn away from commercial work and concentrate on public, nonprofit work. "I'd become a graphic designer so that I could send a message, and I'd lost sight of that," he says. Since then, he has been working tirelessly and almost exclusively on a number of public poster projects associated with regeneration, hope, and spiritual growth, the latest of which, Merry, has spanned the globe.

Tokyo in the 1980s and early 1990s was crazy, a boomtown awash with success and excess in which Mizutani, by his own admission, was totally immersed. "There was a flood of posters that had no communication with their audience, made no connection other than confusing the consumers, and we lost an essential truth of design; namely that even corporations should do good for society and the people." Then the bubble burst. The economy went into free-fall, depression set in, and Mizutani decided that something had to change. "I still had lots of work but I had begun to have this disturbing feeling, which grew day by day, that I was doing something wrong." With the devastation brought by the earthquake, his feelings reached critical mass. Mizutani decided to turn to self-financed personal projects in general, and the social and art poster in particular, as a way out of his spiritually empty lifestyle. He and his team at Mizutani studios bought up media space on the Tokyo underground and in other public areas throughout Japan, and shot and designed three posters on the theme of Come Together For Kobe, with sale proceeds donated towards relief and rebuilding of the city.

The 200th anniversary of SHARAKU 1794-1994 The Mainichi Newspapers

1

VANISHING POINT VANISHING TRIBES OF WORLD

2

1 SHARAKU POSTER This personal project received a gold prize at the prestigious Warsaw poster exhibition.

2 VANISHING POINT Another of Mizutani's early personal projects.

3 COME TOGETHER FOR KOBE Art directed by Mizutani, this poster tried to show what he felt the media wasn't—the scale of the devastation. Lens flare and strong color casts were combined with deliberate fogging and scratching of the original negatives.

"... we lost an essential truth of design; namely that even corporations should do good for society and the people."

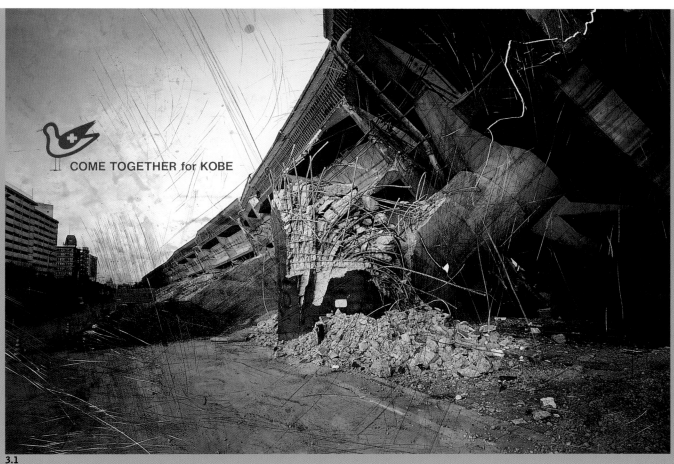

3.1

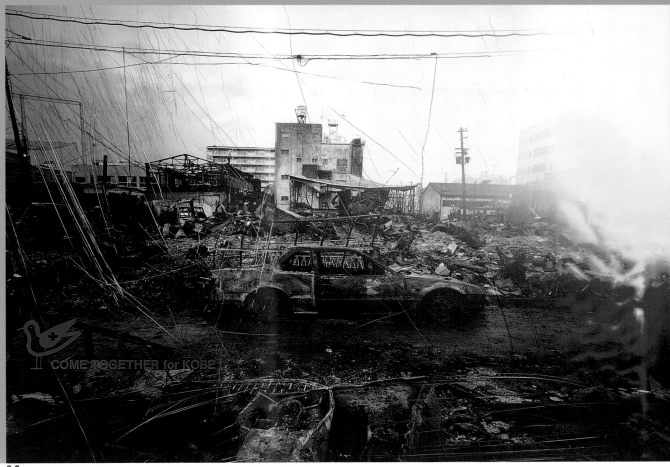

3.2

4.1

4.2

4 MERRY IN KOBE 2001 The 500 photographs for Merry in Kobe 2001—ranging from pictures of an 8-month-old baby to a 97-year-old woman—were taken in a sunflower field on Port Island. The symbol of the revival of Kobe, volunteers planted this field with 300,000 sunflowers. "The sense of hope in both the faces of the subjects and the location chosen is undeniable. Here are people who lost family members, friends, their home, and they're all yet to heal, but they are slowly doing so," says Mizutani.

5 MERRY IN KOBE 2002 Six months before the soccer World Cup began, Mizutani was commissioned by Kobe's City Council to create a buzz about the forthcoming tournament which, for the most part, had left Kobe's residents unengaged and unenthusiastic. Mizutani came to Kobe from Tokyo most weekends and collected over 500 smiles.

5.1

5.2

5.3

5.4

5.5

Posters to inspire

Embarking on a series of personal projects that dealt largely with issues of identity and culture, Mizutani spent the next four years happily working on self-financed projects that were about his desire to "express 'hope' to the world and give a positive message and impression to as many people as possible." One such project was Merry, an enterprise born on the back of a bus in the US in 1999 when Mizutani saw three teenage girls so enjoying themselves, he was moved to capture their spirit of youthful hope and potential. He shot 10 rolls of film and went back to Japan, where he continued to take photos of young people smiling sunnily into his lens. On a purely surface level the images he shot, and continues to shoot, are vibrant examples of the positive energy experienced so purely by most of us only in youth, but beyond that they also bravely thumb their nose at the postironic, negative sneer of Japanese youth at the time. It is impossible to view these images without feeling a positive energy. "In Buddhist thought there's an idea that says if you smile and offer kind words to others you will be happy. The smile is common to every human being on the earth. I would like everyone to gain hope and courage by smiling." To a hardened, cynical, postironic design community it may sound like pure hokey, but there is an undoubted appeal, to which the history of Merry attests.

In 1999, 30 of Mizutani's smiling faces and happy words were collected in the first *Merry* book, and formed the basis of an exhibition at the Hanae Mori Open Gallery in Tokyo. This was followed by exhibitions in Harajuku and Ikebukuro, Tokyo, where Mizutani introduced one-minute Merry images projected onto huge outdoor screens, a burst of color, warmth, and energy for "the people who spent their time in the concrete jungle of the city."

In 2000 Mizutani evolved the project further, holding a site-specific event at the Laforet shopping mall that involved the participation of its visitors in a novel and engaging way. Some 500 A0 (c. 33 × 46¾in) posters were hung around the mall, creating a canopy of smiling faces, and Mizutani kept a digital camera and a large-scale printer with him to enable original posters to be created at the site. Each model wrote something about their feelings, or simply described what the word "merry" meant to them, and these words were incorporated into the exhibition. Approximately 8,000 people were involved during the 12 days of the show.

♡ずーと一緒に笑おうね♡

5.6

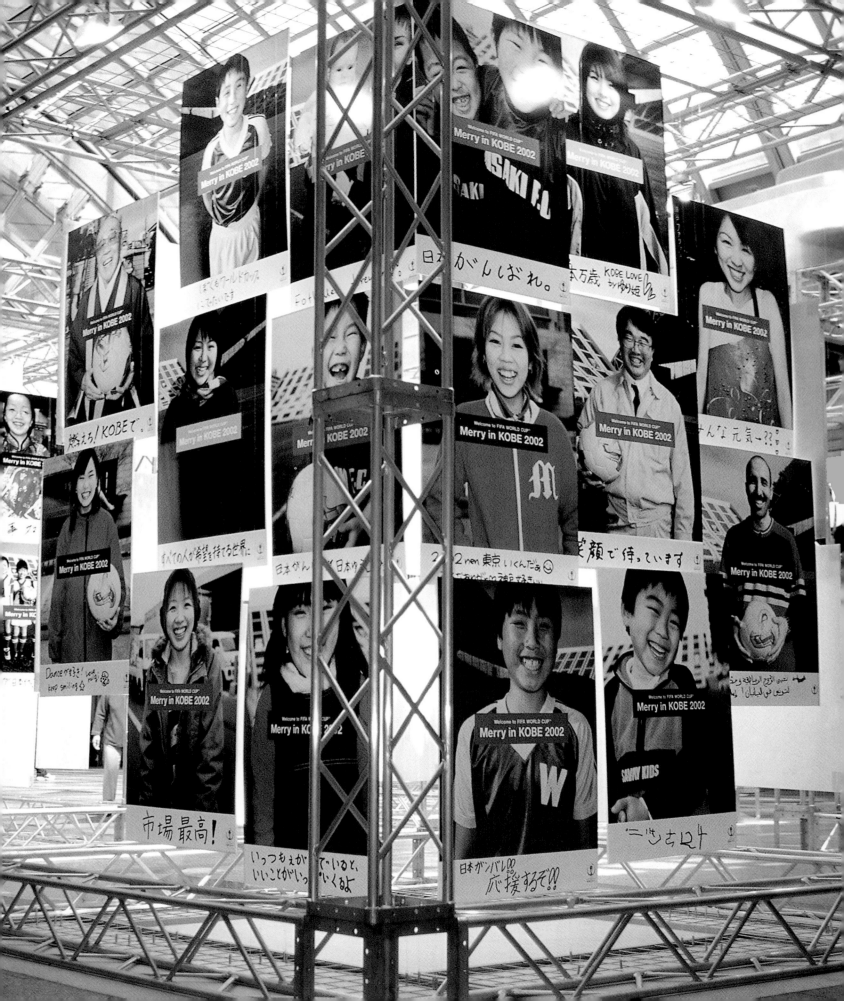

Exhibitions and books

Although Mizutani was convinced of the positive, life-affirming validity of the Merry project, it wasn't until 2001 that his work was married with exhibitions and events, first with Merry in Kobe 2001, then in 2002 with Merry in New York and in 2003, in Kobe again, to coincide with the soccer World Cup. Mizutani was particularly pleased with this move away from Merry's associations with fashion and youth culture. "... holding a Merry exhibition in places with negative inheritance means a lot, because I think it has a much stronger impact on the community and host city."

For each project, Mizutani simply photographs people, mostly young and mostly female, and asks them to write a message about happiness, before editing the results into an exhibition and/or book, often self-published. By way of explaining the heavy feminine bias he says, "Women are more powerful and you can see the future in them, and feel the hope of that future."

Even in the Merry in Kobe 2002 project, which celebrated Kobe's astonishing recovery, to a point where it could act as one of the eight host cities for the World Cup, boys featured in around just 30 percent of photos because, says Mizutani, "the males of Kobe lost their power and therefore their confidence after the earthquake, and weren't as hopeful as the women."

Merry in Kobe 2002 was commissioned by the World Cup Kobe Promotion Committee to turn the tide on the negative feelings being experienced by many Kobe residents. Preparations and work on the World Cup, not just on the stadium but also on welcoming players and supporters from all over the world, were progressing steadily, but there was a lack of enthusiasm at the residents' level, around things like lack of interest in football and a fear of the city being overrun by hooligans. With six months to go before kickoff, the World Cup Kobe Promotion Committee came up with the idea of a Merry project, which was displayed on huge hoardings around the city and at the main station. It's hard to know how great a part the posters played in creating what was one of the most joyful, well-behaved, and well-organized soccer events in history, but there's no denying the icebreaking, tension-diffusing, restorative power of an ear-to-ear grin offered up in innocence, playfulness, and joy.

6 EXHIBITION SITES Other sites for the posters have included the "Duo Dome" in front of the Kobe station transport terminals, the Phoenix Plaza in San'nomiya, and, crucially, as hoarding around the temporary enclosure of the redevelopment construction of the earthquake site, Shin-Nagata Minami. Mizutani feels that the posters were particularly fitting here. "It meant a lot to me to undertake the project at a place where thousands of people were killed by the earthquake."

7 MERRY NEW YORK During a nine-day period in 2002, which included 9/11, Mizutani shot more than 400 pictures of young New Yorkers on the streets of their still recovering city. These formed the basis of an exhibition, "A Year after New York." Wall and floor projections covered the surfaces of the Roppongi Think Tank in Tokyo during February 2003 before going on to a larger scale exhibition at a new museum. The New York pictures were collected into a free A3 (c.11½ × 16½in) magazine distributed first in Tokyo and New York, then worldwide. The publication date was February 14, Valentine's Day. "It was totally hard and depressing walking around ground zero," recalls Mizutani of the photoshoot, "but there were a lot of positive smiles and real hope."

9.11.02 NEW YORK MERRY 2.14.03 TOKYO

MERRY IN NEW YORK AT ROPPONGI THINK ZONE

Merry in KOBE

Koji Mizutani
Text: Tetsuya Chikushi
Kazuyoshi Miura
Itaru Hirano, Kinya Imaizumi

8.1

Feedback

"I'm attracted to this photo collection focusing on the smiles of children in Kobe city for several reasons," enthuses Japanese journalist Tetsuya Chikushi. "On one level, I like the fact that it contradicts the erroneous idea that Japanese children lack facial expressions and a gleam in their eyes. On another, I like the way it shows that children worldwide share something. Last year, when I covered a story about Afghanistan refugee children near the border with Pakistan, the children were very lively in spite of the ultimately harsh living environment thrust upon them. Seeing children with such cheerful, merry expressions was wonderful, and the fact that they share such feelings with the children of Kobe especially so. When ongoing economic predicaments are causing many people to feel stagnant and depressed about their futures, a smile makes a difference. I believe it is our wisdom and fortitude that allows us to accept hardships cheerfully, no matter how difficult they are, and a smile is a huge part of that," he concludes.

8 MERRY BOOKS Most Merry exhibitions were also produced as books. A book of the original Merry exhibition at Laforet was published by Bauhaus, while the Kobe books were published by Kobe Shinkaisya, and cofinanced by Mizutani, as were most Merry projects.

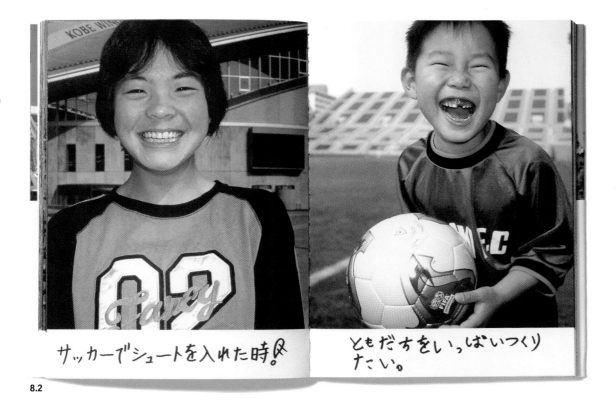

サッカーでシュートを入れた時。

ともだちをいっぱいつくりたい。

8.2

"Holding a Merry exhibition in places with negative inheritance means a lot, because it has a much stronger impact on the community."

thomas.matthews
The Earth Centre

10

thomas.matthews regards ethical practice and issues as central to design, so its work for the Earth Centre, a visitor attraction promoting sustainability, was a great opportunity to explore these issues in depth.

Sustainable development

The Earth Centre's ambition, as the mission statement put it, was to be "the center of first choice for the understanding and application of sustainable development in everyday life." Based at a disused coal mine just outside Doncaster, England, it was initiated as the first project of the newly founded Millennium Commission. This body was established to distribute money raised by the National Lottery to "create a lasting legacy across the UK," namely, a range of sites, attractions, and visitor centers to mark the year 2000.

As an idea, the Earth Centre project had been around since 1990, supported and championed by a diverse group of individuals rather than any single organization. Jonathan Smales, then the director of Greenpeace, was so inspired by the idea of creating a place where visitors could not only read about, but also experience what the best ideas and technologies for living sustainably actually meant, he gave up his job to raise funding for what was then envisaged as a museum of the environment. Former Director of Sustainability Dan Epstein puts it thus: "The Earth Centre was conceived as a place that would communicate and bring to life the difficult and vague concept of sustainability, and help to make it popular and more accessible. We wanted to use the site to demonstrate the best ideas, technologies, and examples of sustainability—seeing is believing. Part of our intention was not only to demonstrate sustainable development through exhibitions and demonstrations, but also to apply the ideas and principles to the way we built and ran the project, so that in itself it became an exemplar of sustainable development."

1 THE SITE IN DEVELOPMENT
The Earth Centre is built on two disused collieries—Denaby Main and Cadeby—in northern England. Rather than attempt to return the area to its "natural state," which would have predated the industrialization of the site, the project focused on optimizing local biological diversity and providing public access within a sustainability framework. New meadows, wetlands, and woodlands were created; new soil from organic waste products was used; stock that would improve the soil quality was planted; and local and recycled materials were used throughout the center.

2 INITIAL SKETCHES (Photo: thomas.matthews) thomas.matthews' original visual idea juxtaposed the natural and the man-made in a series of screen prints which contextualized the idea of sustainability as finding a balance between the two—a theme carried through their designs.

1.1

1.2

"What's great about the Earth Centre is that wherever you go, you realize that everything is recycled or sustainable in some way."

2.1

3.1

3.2

3.3

3.4

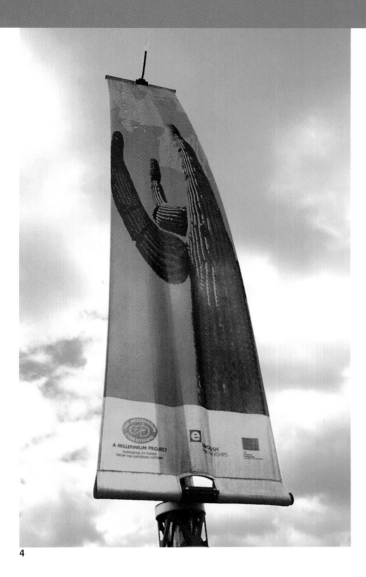

4

Developing the site

Initial feasibility studies rejected several inner-city sites to arrive at Doncaster partly because "there was a lot of history and interesting work to do in areas such as site remediation and community development. We felt this gave the site more substance than if it was simply a demonstration visitor attraction; here we could do sustainable development for real. The local people—many of whom had worked in the mine that once occupied the site, and many of whom were now unemployed—were initially skeptical and cynical about the center, but they came to feel very proud of it," recalls Sophie Thomas, one of the two principals and founders of thomas.matthews. Unfortunately, as the center developed, proposed projects were lost through insufficient funding.

Interpretation and signage

thomas.matthews' involvement came relatively late on in the preopening phase of the center. Originally commissioned to work on print materials for the shop, thomas.matthews ended up designing all the on-site identity for the project, all the signage on buildings and around the gardens, maps, branded shop merchandise, and a range of other materials, such as the wetland exhibition and education materials. "Once on the site, we realized that there was massive potential for interpretation as a way of illustrating the amazing examples of sustainability hidden in the buildings and landscape. For example, using human compost did away with the need for any new topsoil, and the gardens used old recycled bricks from the local town of Conisborough, which perfectly illustrated the idea the center was trying to promote, namely that sustainability is local, national, and global," says Thomas.

3 FINAL DESIGNS FOR BANNERS Imagery to encompass all aspects of life was chosen, mixing images of man and nature to convey connections between the local, national, and global.

4 DRY GARDEN BANNER (Photo: Jennifer Bates) As well as the obvious functions of wayfinding and giving the center a strong visual identity, the banners used throughout the site add a visual height to what would otherwise have been a very flat area. This banner uses the natural motifs and screen-printed style that were among the first ideas collected by thomas.matthews. The shape is reminiscent of a billowing boat's sail. A vane swivels the banner into the wind, and a sliding base allows it to be pushed up and out.

5 DIRECTIONAL SIGNAGE (Photo: Jennifer Bates) Where possible, 100 percent post consumer recycled materials were used and local companies engaged. Directional and interpretational signage used plastic wood made from 100 percent post consumer recycled polystyrene coffee cups and steel. The orange vane reflects the logotype circle for the Earth Centre and moves in response to the wind. As a result, the messages written on the vanes spin and point to a "fantastic future" to be found in every direction at the Earth Centre.

Selecting materials

Less than a year from opening, the Earth Centre was a building site. It was very windy and bare, as there were no mature trees to provide height or act as windbreaks, but it was planned that the center would evolve over time as new areas and projects were added. Any work carried out for the center needed to demonstrate the principles of sustainability throughout its execution. As Thomas says, "What's great about the Earth Centre is that wherever you go on the site, you realize that everything around you is recycled or sustainable in some way. Everything has a sustainable story behind it—pick up a pencil, for example, and it will be made of recycled materials. Sustainability is about changing people's perceptions and breaking old and bad habits; you don't have to shout about it."

Working to a tight budget led to extensive research to find materials that would both fit the sustainability remit of the center in the way they'd been produced and be suitable for their purpose. thomas.matthews was often sourcing materials manufactured for one purpose and using it for another. "There's a real economy of materials going on, making everything do double duty. So a ticket also becomes a pledge card—it's about making things work harder for you." The knowledge gained from this process has proved useful in all the projects that thomas.matthews has carried out since.

All the merchandise and shopping bags for the center support its sustainability message through the graphics incorporated in them and by the way they are sourced and manufactured. The mousemat is made from natural rubber, in keeping with the remit to find environmentally friendly alternatives to materials such as PVC and aluminum.

7.1 7.2

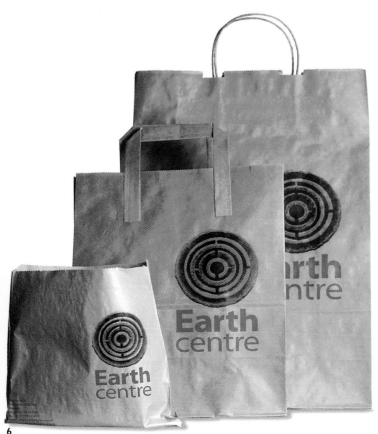

6

6 SHOPPING BAGS (Photo: Matt Shave) The Earth Centre shop's brown paper bags show, on one side, the logo and circular motif. In this instance the motif is a maze. The reverse side shows a list—a recurring element that thomas.matthews introduced across the site and the branding guidelines— that opens with the lines "This bag is 100 percent post consumer waste/This time, don't waste it—use it again to:/Hold your knitting/Take grocery shopping/Transport your kitten to camp ..."

7 MUG (Photo: Matt Shave) The Earth Centre's mug with a message aims to discourage the use of disposable cups. The design reflects thomas.matthews' overall approach to the project: "not 'granola-esque' but colorful and modern."

8 EARTHTRAIL SPREAD (Photo: Matt Shave) The Earth Trail guide is aimed at over-12s and adults and, as with the Earth Adventure guide, contains a mix of activities, information, and voucher offers from related organizations.

9 SITE MAP (Photo: Matt Shave) The map for the center proved particularly challenging, partly because "it's very typical for an environmental project to want to say a lot," says Thomas. Additionally, the site is an unusual shape, compounding the difficulty of producing a friendly, easy-to-use map while taking advantage of the opportunity of getting the Earth Centre's messages about sustainability across. In the interests of both clarity and user-friendly design, thomas.matthews settled on the use of perspective to interpret the site. The reverse of the map carries the screenprinted "nature meets the man-made" imagery that is used throughout the center's communication designs.

10 POND-DIPPING JARS (Photo: Matt Shave) Reusable jars were printed with instructions on how to build a food chain.

Feedback

"This commission made us leave the jobs we were in at the time and set up the company," says Thomas. "The nature of the Earth Centre as a first large client helped set standards for our client base. People saw the Earth Centre work and commissioned us for similar projects."

"Through the work thomas.matthews did on the identity of the Earth Centre, they helped to build bridges across the organization and give the project a much stronger sense of place. We met a lot of different graphic design companies, but we found that very few really understood what we were trying to do, or cared for or understood the subject in any real detail. thomas.matthews did. They also worked effectively with a number of other design companies—including the architects, landscape architects, and exhibition designers—to give the project a sense of coherence. In effect, for nearly two years they became critical members of the client's development team," enthuses Epstein.

"Having originally been taken on to deliver a much smaller, traditional graphic-design scope of works, they became a core part of the team, helping to develop content, style, brand, and products," recalls Epstein. "Finally, they also added a lot of practical knowledge about materials and suppliers that was an important contribution to our ambition to build an exemplary sustainable site," he concludes.

11

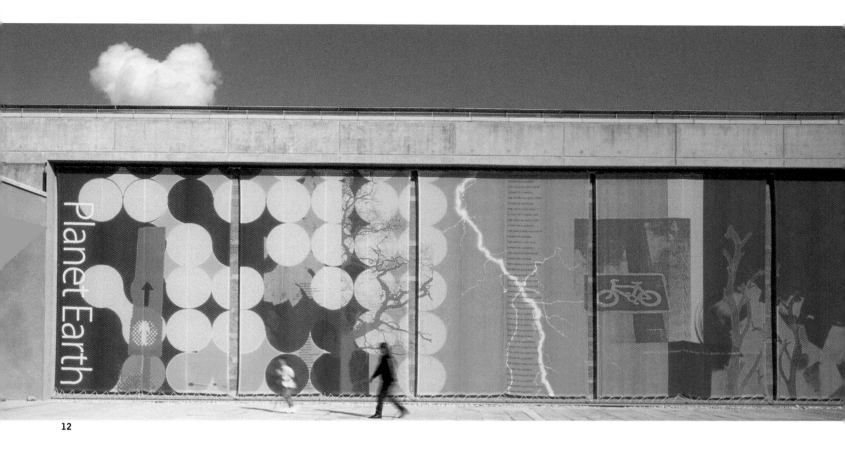

"There's a real economy of materials going on, making everything do double duty."

11 EARTHACTION TAKE HOME GUIDE
(Photo: Matt Shave) This follows
the same format as the other guides.
It enables visitors to continue to
engage with the Earth Centre's ideals
in their everyday life.

12 PLANETEARTH BANNER (Photo:
Dennis Gilbert) All site signage uses
the corporate typeface, Myriad. This
has a large family, making it suitable
for all contexts, from large signs to
small, printed maps. Part of the brief
was that the center have a strong child
and family appeal, which is supported
by the bright, attractive colors used
on the banners.

13 EARTHADVENTURE AND EARTHTRAIL
BOOKLETS (Photo: Matt Shave) These
booklets are used as a way of engaging
visitors with the center and the
sustainability message. Made from
paper pages held together by a metal
ring, they have a hard cover to rest on
when writing responses. The covers,
by Hannah Greenaway, are made from
recycled plastic bags, so each booklet
is unique.

13.1 13.2

Bibliography

Books

AIDS Demo Graphics, Douglas Crimp (Bay Press, 1996)

Art and Propaganda, Toby Clark (Everyman Art Library, 1997)

Attitude: The New Subversive Political Cartoonists, ed. Ted Rall (NBM, 2002)

Below Critical Radar: Fanzines & Alternative Comics from 1976 to Now, Roger Sabin and Teal Triggs (Slab-O-Concrete, 2000)

Billboard: Art on the Road, eds. Laura Stewart Heon, Joseph Thompson, and Peggy Diggs (The MIT Press, 1999)

Brand New, ed. Jane Pavitt (V&A, 2000)

Brand Spirit, Hamish Pringle and Marjorie Thompson (John Wiley & Sons, 2001)

Buckminster Fuller: Anthology for the New Millennium, ed. Thomas T. K. Zung (St. Martins Press, 2001)

A Century of Graphic Design, Jeremy Aynsley (Mitchell Beazley, 2001)

Citizen Designer: Perspectives on Design Responsibility, Steven Heller and Veronique Vienne (Allworth Press, 2003)

Clean New World: Culture, Politics and Graphic Design, Maud Levin (MIT, 2001)

Communicating Design, Teal Triggs (Batsford, 1995)

Constructing Accessible Websites, Jim Thatcher, et al. (Glasshaus, 2002)

Culture Jam: How to Reverse America's Suicidal Consumer Binge, Kalle Lasn (Quill, 1999)

The Democratic Worker-Owned Firm: A New Model for the East and West, D. Ellerman (Routledge, 1990)

Design Culture: An Anthology of Writing from the AIGA Journal of Graphic Design, Steven Heller and Marie Finamore (Allworth Press, 1997)

Design Dialogues, Steven Heller and Elinor Pettit (Allworth Press, 1998)

The Design of Everyday Things, Donald A. Norman (MIT, 1998)

Design Issues: How Graphic Design Informs Society, ed. D. K. Holland (Allworth Press, 2001)

Design for the Real World, Victor Papanek (Thames and Hudson, 1984)

Design Writing Research: Writing on Graphic Design, Ellen Lupton and Abbott Miller (Phaidon, 1996)

The Eco-design Handbook: A Complete Sourcebook for the Home and Office, Alastair Fuad-Luke (Thames and Hudson, 2002)

From ACT UP to the WTO, Benjamin Shepard and Ronald Hayduk (Verso, 2002)

The Global Activist's Manual: Local Ways to Change the World, Mike Prokosch and Laura Raymond (Thunder's Mouth Press/Nation Books, 2002)

Graphic Agitation, Liz McQuiston (Phaidon, 1995)

Graphic Design Time Line, Steven Heller and Elinor Pettit (Allworth Press, 2000)

Green Design: Design for the Environment, Dorothy Mackenzie (Laurence King, 1991)

The Hidden Persuaders, Vance Packard (Random House, 1957)

The Humane Interface: New Directions for Designing Interface Systems, Jef Raskin (Addison-Wesley, 2000)

Information Design, ed. Robert Jacobson (MIT, 2000)

Information Graphics, Peter Wildbur and Michael Burke (Thames and Hudson,1998)

in sight: a guide to design with low vision in mind, Michael Evamy and Lucienne Roberts (RotoVision, 2003)

Looking Closer 4: Critical Writings on Graphic Design, eds. Michael Bierut, William Drenttel, and Steven Heller (Allworth Press, 2002)

No Logo, Naomi Klein (Flamingo, 2001)

Posters American Style, Therese Thau Heyman (Harry N. Abrams, 1998)

Problem Solved: A Primer in Design and Communication, Michael Johnson (Phaidon, 2002)

Rising Tides: The Environmental Revolution and Visions for an Ecological Age, Rory Spowers (Cannongate Books, 2003)

Shock in Advertising, Dave Saunders (Batsford, 1996)

Social Work: Saatchi & Saatchi's Cause-Related Ideas, Saatchi & Saatchi (Two-hundred Seventy Three Publishers, 2000)

This is what we do – a MUF Manual, Katherine Shonfield (Ellipsis, 2001)

Tibor Kalman, Perverse Optimist, eds. Peter Hall and Michael Bierut (Princeton Architectural Press, 2001)

Workplace Democracy: A Guide to Workplace Ownership, Participation and Self-management Experiments in the United States and Europe, Daniel Zwerdling (Harper and Row, 1984)

Reports
"Access Prohibited, Information for the Design of Public Access Terminals," John Gill (RNIB, 1998)

"Graphic Design For AIDS," Chaz Maviyane-Davies (Design for the World, 2002)

"Picturing A Life Free of Violence," ed. Jenny Drezin (UNIFEM, 2001)

"Small Print," Frank Philippin (Report for the Helen Hamlyn Research Associates Programme, 2000)

Magazines
Adbusters (Canada)

Creative Review (UK)

Graphics International (now *Grafik*) (UK)

Print (US)

Step Inside Design (US)

Contact Details

Caro Howell
caro.howell@btopenworld.com

Daniel Porter
www.danporter.info
dan@danporter.info

Design for the World
Palau de Pedralbes (Annex)
Av. Diagonal, 686
08034 Barcelona
Spain
Tel:+34 (93) 206 36 86
www.designfortheworld.org
info@designfortheworld.org
Director: Dirk Bogaert

Eat
Zamenhofstraat 150
Unit 431
1022 AG Amsterdam
The Netherlands
Tel: +31 (0) 20 494 0130
www.eat-this.nl
you@eat-this.nl

Eleanor Ridsdale
120 Ruskin Park House
Champion Hill
London SE2 8TH
UK
Tel: +44 (020) 7326 0508
eleanorridsdale@mac.com

Flat Inc.
3rd Floor
391 Broadway
New York, NY 100013
USA
Tel: +1 (646) 613 8833
www.flat.com
info@flat.com
Founding partners: Tsia Carson,
Doug Lloyd

Helen Hamlyn Research Centre
The Royal College of Art
London SW7 2EU
UK
Tel: +44 (020) 7590 4242
www.hhrc.rca.ac.uk
hhrc@rca.ac.uk
Directors: Roger Coleman,
Jeremy Myerson

i-Map
www.tate.org.uk/imap/

John Cranmer
j.cranmer@freenet.co.uk

Mizutani Studio
1202 Taichi-Roppongi Building
6-3-15 Roppongi
Minato-ku
Tokyo 106-0032
Japan
Tel: +81 (03) 3478 1931
www.remus.dti.ne.jp/~mizutani
mizutani@remus.dti.ne.jp
Founding partner: Koji Mizutani

Modern Dog Design Co.
7903 Greenwood Avenue
N Seattle WA 98103
USA
Tel: +1 (206) 789 7667
www.moderndog.com
bubbles@moderndog.com
Founding partners: Robynne Ray,
Michael Strassburger

**RNIB (Royal National Institute of
the Blind)**
105 Judd Street
London WC1H 9NE
UK
Tel +44 (020) 7388 1266
www.rnib.org.uk

Sagmeister Inc.
222 West 14 Street
Suite 15a
New York, NY 10011
USA
Tel: +1 (212) 647 1789
www.sagmeister.com
info@sagmeister.com
Founding partner: Stefan Sagmeister

Studio Dumbar
Lloydstraat 21
3024 EA Rotterdam
The Netherlands
Tel: +31 (0) 10 448 22 22
www.studiodumbar.com
info@studiodumbar.nl
Creative Directors: Gert Dumbar,
Michel de Boer

S-W-H
Hoogte Kadijk 143 F26
1018 BH Amsterdam
The Netherlands
Tel: +31 (0) 20 422 2999
www.s-w-h.com
mail@s-w-h.com

thomas.matthews
Unit 4
51 Tanner Street
London SE1 3PL
UK
Tel: +44 (020) 7403 4281
www.thomasmatthews.com
info@thomasmatthews.com
Principal partners: Sophie Thomas,
Kristine Matthews

Worldstudio Foundation
200 Varick Street, Suite 507
New York, NY 10014
USA
Tel: +1 (212) 366 1317
www.worldstudio.org
info@worldstudio.org
Founder and President: David Sterling
Vice-president: Mark Randall

Yolanda Zappaterra
yz@liketv.com

Picture Credits

Unless otherwise noted in the caption, all pictures kindly provided by the respective designers, companies, and agencies.

p 6 One Person, Two Votes psa Flat Inc.

p 11 I Love New York poster Milton Glaser, 2001

p 12 War is Over billboard Hulton Archive/Getty Images

p 13 War is Good Business poster Design by Seymour Chwast, The Pushpin Group, New York

p 14 Hitler poster V&A Images, The Victoria and Albert Museum, London

p 14 War is Not Healthy poster This image and text is a registered trademark and copyright 1968/2003 of Another Mother for Peace, Inc. ("AMP"). Used by permission of AMP. From the collection of the Center for the Study of Political Graphics, Los Angeles.

p 15 Saddam and Bush in Bed Together poster Sue Coe: Saddam and Bush in Bed Together. Copyright © 1992 Sue Coe. Courtesy Galerie St. Etienne, New York

p 16 Freedom From Choice poster Robbie Conal

p 17 Hail to the Thief poster Robbie Conal

p 19 Birth-control poster Gert Dumbar

p 20 Come Together for Kobe poster Koji Mizutani

p 21 Don't be Afraid of the Dark psa Flat Inc.

p 22 AmphetaZINE page Modern Dog Design Co.

p 24 TrueMajority slide card Stefan Sagmeister

p 25 Sphere magazine cover Worldstudio Foundation

p 27–29 Working sketches Worldstudio Foundation

p 91 Picasso "Bowl of Fruit, Bottle and Violin" © Succession Picasso/DACS 2003

p 94 Matisse "The Moroccans" © Succession H. Matisse/DACS 2003 © 2003, Digital Image, The Museum of Modern Art, New York/Scala, Florence

Time line
Time line compiled by Yolanda Zappaterra, Steven Heller, Jeremy Myerson, Michael Johnson, Malcolm Garrett, Peter Hall, and John Cranmer.

p 10 Mary Lowndes banner The Women's Library/Mary Evans Picture Library

p 10 William Morris V&A Images, The Victoria and Albert Museum, London

p 11 Rodchenko poster V&A Images, The Victoria and Albert Museum, London

p 11 John Heartfield skeleton poster V&A Images, The Victoria and Albert Museum, London

p 12 Harry Beck Tube map London's Transport Museum

p 12 Isotype Handbook of Pictorial Symbols: 3250 Examples from International Sources, Rudolf Modley, Dover Publications

p 13 Spanish Civil War poster BUSCW: 204 Spanish Civil War Collection, Robert D. Farber, University Archives and Special Collections Department

p 13 Abram Games war poster V&A Images, The Victoria and Albert Museum, London

p 14 The Hidden Persuaders cover Cover of The Hidden Persuaders, Vance Packard (Penguin Books, 1981) cover copyright © Penguin Books, 1981

p 14 CND symbol Courtesy of CND

p 15 OZ magazine cover

p 15 Amnesty International image Courtesy of Amnesty International (www.amnestyusa.org)

p 16 Motorway signs PA Photos

p 16 First Things First manifesto

p 17 Black Panther Party poster

p 17 Abortion poster Chicago Women's Graphic Collective

p 18 Atelier Populaire policeman graphic V&A Images, The Victoria and Albert Museum, London

p 18 EAT poster V&A Images, The Victoria and Albert Museum, London

p 19 Taste and Style poster Designed by Sheila Levrant de Bretteville

p 19 Design for the Real World cover Courtesy of Thames & Hudson UK

p 20 Sniffin' Glue cover Mark Perry

p 20 Buzzcocks "Spiral Scratch" cover Courtesy of Richard Boon and Malcolm Garrett

p 21 Peter Kennard poster V&A Images, The Victoria and Albert Museum, London

p 21 Barbara Kruger poster Collection: Broad Art Foundation Courtesy: Mary Boone Gallery, New York

p 22 Apple computer Photo Courtesy of Apple Computer Inc.

p 22 Guerrilla Girls Courtesy of www.guerrillagirls.com

p 23 Gran Fury poster Gran Fury Collection, Manuscripts and Archives Division, The New York Public Library

p 23 Anti-Disney image James Victore

p 24 Colors magazine cover Courtesy of Colors magazine

p 24 Friends of the Earth poster Friends of the Earth

p 25 Big Issue logo Reproduced by kind permission of The Big Issue Company Ltd.

p 25 Adbusters cover Image courtesy of www.adbusters.org

p 26 Tiresias font Scientific Research Unit, Royal National Institute of the Blind

p 26 Sudan poster Courtesy of Luba Lukova

p 27 George Bush poster Courtesy of johnson banks

p 27 No Logo cover Courtesy of HarperCollins Publishers Ltd. © 2000 Naomi Klein

p 28 Scope map ©TFL Reproduced with kind permission of Transport for London

p 28 Not in Our Name ad. Designed by Sheila Levrant de Bretteville

p 29 Micah Wright poster Courtesy of Micah Wright

p 29 Fuck the War poster Bodhi

pp 88–89 Works returning from storage in Underground Courtesy of London's Transport Museum

Index

Adams Morioka 121
Adams, Sean 121
Adbusters 7, 16, 25
Adobe Systems 115, 119, 127, 130
Aink, Mark 44, 47
Americans with Disabilities Act
 (ADA) 22
AmphetaZINE 22, 24, 64–75
Art Directors Club of Netherlands
 (ACDN) 19
arts and crafts movement 14
Ashcroft, Peter 87
Asselbergs, Pam 19, 44–9, 50
Atelier Populaire 18
Atrissi, Tarek 127
Azevedo, Paula 129

ballot papers 21
Bangladesh Birth-Control Project 23,
 98–109
Baptiste, Michel 130
barefoot doctors 103–4
Bauhaus 12, 14
Beck, Harry 12
Bierut, Michael 125
Bogaert, Dirk 20, 25
books 139, 143
Boon, Richard 20
Brennan Center for Justice 56
British Academy of Film and Television
 Arts Award (BAFTA) 97
British Heart Foundation 23, 77
Bronx Museum of Arts 56
Buddhism 137
Business Leaders for Sensible
 Priorities 32
Byrne, David 115

Calvert, Margaret 16
Carson, Tsia 21, 56, 58, 125
Chavalit, Wonravee 127
Chemo, Joe 112, 115
Chicago Women's Graphic
 Collective 17
Chikushi, Tetsuya 143
children 12, 19, 21, 47
Chowdhury, Zafrullah 100, 104, 108
Chwast, Seymour 13
clients 20, 28–9, 112, 119, 121, 127,
 134, 154

Co-operative Movement 27
Cohen, Ben 32, 36, 38, 40
collateral damage 15
commercial work 134
common sense 100
Communism 14, 36
Conal, Robbie 16–17
Congress 38
constructivism 14
content 73–5
contextualization 29
contracts 28
conventions 100
copyright 24, 27
Corporate Conscience Award 44
Countryside Agency 78, 87
cultural references 103
culture jamming 16

Dae Hyuk Sim 125
Desert Storm 15
Design for the World 24–5
disabilities 21–2, 27, 89, 90
Disability Discrimination Act 22
distribution 73–5
Dumbar, Gert 19, 23, 98–109

Earth Centre 144–55
Eat 19, 42–53
Ecole d'Art 18
Ecover 19, 42–53
effective design 21, 40, 75
Elliman, Paul 115
employee-owned businesses 27
Epstein, Dan 146, 154
ethical companies 27
European Business Ethics Network 27
exhibitions 137, 139, 151

Fairtrade 28
feedback 40, 53, 63, 69
 i-Map 90, 97
 AmphetaZINE 73, 75
 Bangladesh Birth Control 108
 Earth Centre 154
 Merry in Kobe 143
 Sphere 127
 Walking to Health 85, 87
finances 27
Fisher, James 69
Flash animation 90

Flat 21, 54–63, 125
Flrt.com 58–9, 63
flyers 15
Flyleaf 129
focus groups 83, 85
Fong, Karin 122
futurism 14

Games, Abram 13
Garland, Arch 129
Garland, Ken 20
Gellman, Tricia 127, 130
Gill, John 21
Glaser, Milton 11–12, 29, 115
global warming 36, 38
globalization 16, 36
Golden Environment Medallion 44
Gonoshasthaya Kendra 100
Grant, Bill 120
Grapus 17, 18
Great Hanshin Earthquake 134, 139
Greenaway, Hannah 155
Greenpeace 146
Guardian 27
guerilla design 16–17
Guerilla Girls 22

Haeberle, Ronald 15
Hall, Peter 115, 127, 130
Hanae Mori Open Gallery 137
health education 100
Heartfield, John 11, 14, 16
Heimlich maneuver 13
Helen Hamlyn Research Centre 22,
 77–8
Heller, Steven 10–17, 29
history 10–17
Holzer, Jenny 115
honesty 29, 49, 63
Howell, Caro 24, 88–97
human rights 36

i-Map 24, 88–97
illiteracy 100
Imaginary Forces 122
inclusivity 22–5, 29, 73, 81, 89–90, 97
InDesign 119, 130
infotainment 16
inspiration 50–3, 112–15, 137

International Planned Parenthood
 Federation 108
Internet 15, 27, 54–63, 88–97
interpretation 151
irresponsible design 11–14, 29

Jaar, Alfredo 115
Jamboktar, Ashwini 127, 130

Kalman, Tibor 24, 32
Katahira, Kiki 125
Keighley Women's Group 78, 81
Kennard, Peter 21
Kingston, Susan 75
Kinnear, Jock 16
Kobe 20, 132–43
Kruger, Barbara 21
Kyoto Accords 36

Lal, Rikesh 130
Lane, Allen 58
Lasn, Kalle 7
legibility 21–2
legislation 22
Lennon, John 12
Lloyd, Doug 56
Lowndes, Mary 10

Martens, Ludo 49, 53
material selection 152, 154
Matisse, Henri 90
Media Foundation 7
Meijer, Xander 47
mentorship 115, 119–22
merchandise 34–6, 152
Merry in Kobe 132–43
MetaDesign 127
de Michiell, Robert 130
Millenium Commission 146
Mizutani, Koji 20, 132–43
Modern Dog Design 22, 23, 64–75
modernism 14
Morioka, Noreen 121
Morris, William 10
Move Our Money 32–41

National Center for Employee
 Ownership 27
National Lottery 146
National Organization for Women
 (NOW) 17